CINCINNATI'S
HYDE PARK

CINCINNATI'S
HYDE PARK

A QUEEN CITY GEM

GREGORY PARKER ROGERS

Charleston London

THE
History
PRESS

Published by The History Press
Charleston, SC 29403
www.historypress.net

Copyright © 2010 by Gregory Parker Rogers
All rights reserved

First published 2010

Manufactured in the United States

ISBN 978.1.59629.900.9

Library of Congress Cataloging-in-Publication Data

Rogers, Gregory Parker.
Cincinnati's Hyde Park : a brief history of a Queen City gem / Gregory Parker Rogers.
p. cm.
Includes bibliographical references and index.
ISBN 978-1-59629-900-9
1. Hyde Park (Cincinnati, Ohio)--History. 2. Cincinnati (Ohio)--History. 3. Hyde Park
(Cincinnati, Ohio)--Buildings, structures, etc. 4. Cincinnati (Ohio)--Buildings, structures,
etc. 5. Neighborhoods--Ohio--Cincinnati--Case studies. 6. City planning--Ohio--
Cincinnati--History. I. Title.
F499.C57H937 2010
977.1'78--dc22
2010030758

For Kathy, Samantha, Parker, Caroline and, especially, for Mom.

CONTENTS

CONTENTS

ACKNOWLEDGEMENTS

The idea for this book began in the spring of 2005, in the midst of one of Hyde Park's many land-use disputes. I was and am a member of the Hyde Park Community United Methodist Church. Our building committee suggested renovation and expansion of our two buildings, and this drove a good number of our neighbors to put signs in their yards in protest. Several church members who live in Hyde Park volunteered to knock on the neighbors' doors to find out why. So, Jan Seymour, my son, Parker, and I knocked on many doors on the streets near each building. The conversations about the church and its plans were interesting, but neighbors' recollections about the way Hyde Park used to be, and how it has changed, fascinated me. I learned that there was an Ohio governor from Hyde Park (it turns out that there are two) and that he lived in a great house where Clark Montessori sits. I wanted to learn more, and I got the chance when Joe Gartrell of The History Press called in September of 2009 and asked me to write this book.

I have many people to thank: Mike Judy and Randy Cooper, great-grandsons of Myers Y. Cooper, provided information and many pictures, a number of which are included within this book. Tom Compton allowed me to use his pictures of the aftermath of the March 1917 tornado. Rob Kranz provided me with his 1982 photos of the dilapidated Ault Park Pavilion. (Rob and I have a friendly disagreement about whether Ault Park is in Hyde Park or Mount Lookout. Rob insists the park is in Mount Lookout.) I learned how to use the Public Library of Cincinnati and Hamilton County; the people there were most helpful. I spent hours at the Cincinnati Historical Society

and I could spend many more. The review of the Hyde Park Syndicate papers, the Kilgour family papers and the Wulsin family papers proved fascinating. Anne Shepherd at CHS was wonderful.

A number of other people helped to make this book possible: Samantha Rogers, Caroline Rogers and Annie Vehr were my research assistants. Doreen Canton and Rudy Heath gave me superb editing assistance and other advice. Eric Holzapfel, Carl Uebelacker and Jack Cover provided their insight and opinions. Roger F. Weber made the maps in the book. Joe Gartrell and Amber Allen at The History Press were of great help in getting this project finished.

My Labor Department co-workers at Taft Stettinius & Hollister made this happen, too. I have been privileged to be a part of this group for twenty-one years—there is no better group of people. My late partners Roger A. Weber and J. Alan Lips were my mentors who taught me a lot about labor law and a lot about life. My partner Justin Flamm especially contributed a lot of ideas and a lot of details for this project. My assistant, Sharon Staton, typed every one of the words in this book and provided other good and valuable help.

Thanks go to my children and especially my wife, Kathy, for their love and support. And thanks to Mom, who told me in 1989 to move to Hyde Park. I'm glad I took her advice.

May 2010

INTRODUCTION

Traveling eastbound on Columbia Parkway from my downtown office isn't a problem this Tuesday night. The Ohio River is a fantastic shade of blue, about one hundred feet below the parkway just on the other side of Riverside Drive. The air is clear and you can see all the way to Columbia Tusculum, home to Cincinnati's first settlers in 1788. Traffic is moderate; my children are hungry and restless, anxious for my arrival. My wife is out for dinner with a business associate from out of town. Fortunately, I time the stoplights at either end of Torrence Parkway correctly and soon I'm on Madison Road, one of the oldest roads in Hyde Park, full of undulating hills between Grandin Road and Erie Avenue. Traffic slows a bit through Hyde Park Square, which appears pretty much as Hyde Park's founders envisioned it in the 1890s when they planned it well—except for the lack of parking spaces.

One minute later I'm home in one of Hyde Park's older subdivisions, Ben-Ve-Nuto, which was mostly built between 1915 and 1925. These are the houses on Ziegle, Monteith, Victoria and Outlook Avenues. Ziegle was originally the driveway off of Paxton Avenue to the home of Louis Ziegle, the first mayor of Hyde Park after it became a village. My home was built in 1915 by Myers Y. Cooper, who built many of the houses in Hyde Park both before and after he served as Ohio governor from 1929 to 1931.

Homework is finished already except for the high schooler—her homework never is complete. It's a May evening, warm enough to walk to the square for dinner. Now that the little one is nine she can make the ten-minute journey with only a modest amount of complaint.

Four blocks later we are at Arthur's, in a 1913 building one block off the square on Edwards Road. Arthur's has been around for more than forty years. Murals have been painted on the walls of some of the regulars, but these paintings were done between twenty and twenty-five years ago. The twenty-five- and thirty-five-year-olds depicted on the walls are now somewhere between their mid-forties and retirement age. But on the walls of Arthur's they are frozen in time. Before my children were born, Arthur's was only the northern half of the building and Hyde Park Dry Cleaners occupied the southern half. Arthur's took the whole space in the early 1990s to double its seating. Tuesday night is Burger Madness, but the kids love the buffalo chicken wings. We say hello to Tim, our new pastor at the Hyde Park Methodist church, and his wife, Kim, who are on their way out as we head inside.

After dinner, the kids persuade me that Graeter's ice cream is a good idea. We pass by the Echo Restaurant, a tenant since 1947 in the Mills Judy Building (originally the Burch Flats), which stands at the corner of Erie and Edwards. The Echo isn't open on Tuesday nights; I prefer going there for breakfast with the regulars, who have their regular seats and their regular orders. Graeter's has been a tenant in this building since 1938, even longer than the Echo. It is Cincinnati's most-beloved ice cream. Aglamesis Brothers, in nearby Oakley Square, gives Graeter's a run for my money, but the kids will hear nothing of it.

Because it is May and folks have been cooped up all winter and early spring, it seems as though everyone is at Graeter's tonight—the line is out the door, onto the sidewalk. Classmates of my children from the Saint Mary School abound, and I catch up with some of the parents I haven't seen for a while. You will see runners virtually all day throughout Hyde Park, and today is no exception. While I'm talking, John and Julie from my Saturday Morning Running Group breeze past heading homeward, eastbound on Erie, working off some of their weight while I add to mine. I will see them Saturday at 7:00.

My older two get the black raspberry chip, while the youngest chooses the cookie dough chip. I induce them to cross partway across Erie onto the square itself, so that I can hear the sounds of the Kilgour Fountain and watch the young children eagerly playing in the jets from the base of the fountain while their parents rush to keep pace. I wonder what Charles Kilgour would think if he could return to this place he planned 120 years ago with his brother John and the other members of the Hyde Park Syndicate. I'm not sure it's exactly what they planned, but it can't be far off. The large buildings on the four corners of the square were finished between 1890 and 1908, and

the balance in between were completed between 1910 and 1932. No matter how many times I visit the square, I always take in something new that I had not noticed before.

The ice cream is finished now and it is time for the short walk home. But before we can leave the square I hear my name being called, and I turn to see Gail, the widow of one of my business partners. She's doing the same thing that I am. She is with her two grown daughters and grandchildren, eating ice cream and taking in the scenery. I remember the high school and college graduations of their daughters, and the girls' weddings. The passage of time is only too evident upon observing how big the grandchildren have become. The sun is beginning to set to the west over Withrow High School, which has stood at the end of Erie Avenue since 1919. After we finish talking, my children and I start to walk a few blocks east in order to finish homework and get ready for bed. It is time to go home.

I've spent what seems like a million nights this way over the twenty years I have lived in Hyde Park. What follows now is a brief history of this Queen City Gem.

HYDE PARK TODAY

Hyde Park today is substantially faithful to the 1890s plan set out by its original promoters. It retains many of the characteristics of a turn-of-the-twentieth-century small village; it is one of few Cincinnati neighborhoods that has a park in the middle of its central retail district. It is a neighborhood dedicated to single-family homes and yet it has century-old apartments on Hyde Park Square and a mix of multiple-family dwellings throughout. The number of churches, on a per capita basis, is among the greatest of the city's other fifty-one neighborhoods. And most churches are within easy walking distance for Hyde Park's thirteen thousand residents.

The neighborhood is a haven for runners, walkers and dog walkers, with sidewalks on virtually every street, and where scenic views abound. Many residents can still walk to their destination instead of drive. It is home to a 224-acre park and the nation's oldest working observatory. Given that the neighborhood offers both inexpensive apartments and multimillion-dollar houses, it is home to people of a great mix of ages, although not a great mix of races—Hyde Park is 93 percent Caucasian, according to the 2000 census. Much of the housing stock is expensive by Cincinnati standards, though not by the standards of many other United States metropolitan areas.

Hyde Park Square, which has been short of adequate parking since automobiles became commonplace, has evolved over the years. The last building constructed on the square was finished by 1932 and most were built earlier. The square originally was home to neighborhood shops such as groceries, meat markets, flower markets, dry cleaners and shoe-repair stores.

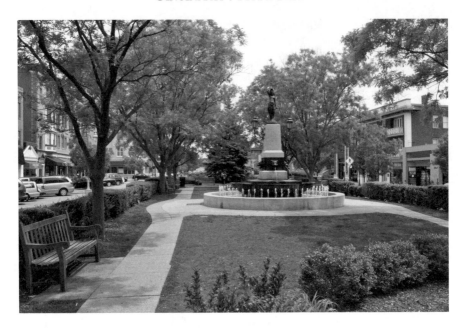

Hyde Park Square in 2010. *Courtesy of the author.*

It was *the* retail center for neighborhood residents before the invention of the shopping mall. Residents would walk or take the electric trolley to the square to do their shopping. This changed gradually over time with the evolution of the automobile and the shopping mall. Hyde Park Square retail today is home principally to specialty stores, restaurants and bars. But Graeter's ice cream has been a tenant on the square since 1938.

Hyde Park is convenient to downtown via a three-mile stretch of Columbia Parkway, which offers breathtaking views of the Ohio River and the valley into northern Kentucky. The neighborhood also has easy access to Interstate 71 and to Interstate 75 via the Norwood Lateral, which takes the traveler to workplaces, the airport, shopping malls and area points of interest.

The boundaries of Hyde Park are ill-defined but it has expanded over the years. Hyde Park was an independent village from 1896 to 1903 before it was annexed by the City of Cincinnati. At that time, its borders were Observatory Avenue to the south, Madison Road to the northwest, Wasson Road to the north and Marburg Avenue to the east. Southeast of Observatory Avenue was Mount Lookout; to the southwest, including the Rookwood subdivision and the Cincinnati Country Club, was East Walnut Hills. Today, on Hyde Park's western end, the neighborhood extends south

Courtesy of Roger F. Weber.

all the way to Columbia Parkway to include Rookwood and the country club. The southern border on the east with Mount Lookout remains uneasy, but it is located somewhere north of Mount Lookout Square. Hyde Park's northern border with Oakley is not well-defined either, but it probably runs along Wasson Road to Marburg Avenue. Hyde Park also would include East Hyde Park, the Hyde Park Golf and Country Club, and the subdivisions adjoining the country club.

Hyde Park is home to a good number of people who care very deeply about the neighborhood, and it is home to many who oppose change to the 120-year-old area in the midst of a constantly changing world. This opposition likely accounts for the significant numbers of land-use battles before various zoning commissions and courts over the years, who have had to settle disputes about how Hyde Park land can be used. History shows that challenges will almost inevitably arise where landowners seek new uses of property—especially where change is sought from single-family residential uses to other uses.

The City of Cincinnati turned two hundred years old in 1988, and a *Bicentennial Guide* to the city's history was commissioned. The authors of this guide some twenty-two years ago described Hyde Park as having "a sense of community that is widespread but not all inclusive." Hyde Park residents may find this view a bit harsh and unfair, but it is a view held by some. It may

also be a view consistent with the writer of the 1908 pamphlet *Hyde Park In Its Glory: A Historical Sketch*, which offers the following observation:

> *As the resident of Hyde Park returns to his home in this congenial and pleasant suburb, he has but one thought and that is while doubtless the Creator could have made a more picturesque and beautiful suburb, it is doubtless true, that he never has.*
>
> *It is distinguished by the absence of characteristics which so often mar an otherwise beautiful suburb. Not a factory within its limits. Its streets broad and well kept. The homes all uniform and attractive. Its residents gathered to this green valley by the attraction of its beauty and happy spirit of its fellow citizens. What is seen today is in many ways the outgrowth and result of many years of labor.*

Hyde Park is a unique neighborhood within the City of Cincinnati with an interesting story.

FARMLAND BECOMES MORNINGTON

1794–1884

The area that today is Hyde Park was settled first by Native Americans. They left after the 1795 signing of the Treaty of Greenville[1] relinquished the claims of the Indian tribes to most of present-day Ohio and Indiana. This opened what would become Hyde Park to settlement, principally for farmland, by some of Cincinnati's first permanent inhabitants. These settlers found their way up the hill from their farms on the north bank of the Ohio River, which they made after their landing in the area in 1788. The neighborhood became known as Mornington in about 1823, named for the local schoolhouse. In addition to farmland, though, beginning in 1827, several grand country estates began to appear. Farmland and country estates, then, comprised the area until train transport and streetcars were connected to Mornington and its transformation began in the mid-1880s.

THE MIAMI PURCHASE

The first permanent settlement in Ohio was on April 7, 1788, when members of the Ohio Land Company founded Marietta at the confluence of the Ohio and Muskingum Rivers. Six months later, on October 15, 1788, John Cleves Symmes of Morristown, New Jersey, a member of the Continental Congress, joined with Jonathan Dayton, Elias Boudinot and others to contract with the United States Treasury Board to buy 1 million acres—at a dollar an acre—of what became southwestern Ohio. The syndicate could

not meet the payments in full, and in 1794 it finally closed on 311,682 acres, comprising all of the land between the Great Miami River and the Little Miami River, south of a line near the northern borders of today's Warren and Butler Counties. This became known as the Miami Purchase, named for the Miami Indians who inhabited this land at that time.

FROM COLUMBIA TO HYDE PARK

The first permanent settlement in the Miami Purchase was started by twenty-six people, including Benjamin Stites, Isaac Ferris and Thomas Wade, on November 18, 1788, at Columbia—part of today's Columbia Tusculum[2] and namesake of Columbia Parkway—near the confluence of the Ohio and Little Miami Rivers.

The next settlement, on December 28, 1788, was Losantiville, opposite the mouth of the Licking River. Losantiville is a mixture of Latin, Greek and French and was supposed to mean the "city opposite the Licking River." The first governor of the Northwest Territory, General Arthur St. Clair, changed the name of Losantiville to Cincinnati. This was in honor of the Society of the Cincinnati, an organization of George Washington's officers who respected Washington's decision to leave the army and the government upon the conclusion of the Revolutionary War. The society was named after the Roman general Lucius Quinctius Cincinnatus, who led Rome to victories in both 458 and 439 BC and then retired to his farm after each victory rather than stay in government as dictator.

Fort Washington was built in downtown Cincinnati in 1790, and Fort Hamilton was built in 1791, to help ward off attacks by Native Americans. Indians were removed from the Miami Purchase after the signing of the Treaty of Greenville in 1795, and the white population spread quickly thereafter throughout these lands, including the settlement of the area that today is Hyde Park.

THE FIRST ROADS

The first roads laid out, mostly along old Indian trails, included Observatory Avenue, Grandin Road, Edwards Road, Paxton Avenue, Linwood Avenue and Madison Road. Observatory, originally known as City Road or Hogback Road, was present at least as early as 1792, and it extended from Peebles

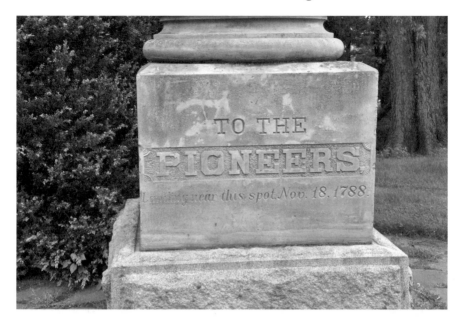

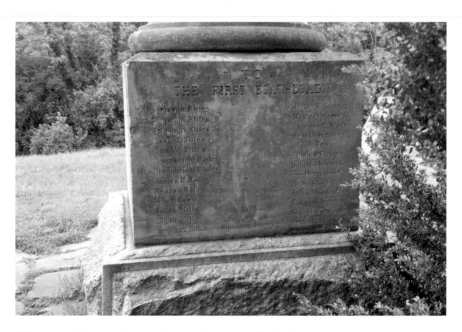

This page: A pillar stands in the Pioneer Cemetery off of Wilmer Avenue commemorating the Columbia landing party in 1788, and their founding of The Columbia Baptist Church in 1790. *Courtesy of the author.*

Corner in Walnut Hills all the way to Chillicothe. Maps as late as 1905 show that it extended all the way through what became Ault Park to Red Bank Road. It was renamed Observatory no later than 1891, eighteen years after the Cincinnati Observatory Center was moved to the area. Grandin Road runs along an old Indian trail and it is named for Philip Grandin, who owned hundreds of acres along the road and made his money in the steamboat industry. Edwards Road also was an old Indian trail that originally ran along this path from the Ohio River to Duck Creek; it became a pike in 1830. Neighborhood residents provided the funding to have the street widened and resurfaced in 1863 when it became known as Edwards Road. It is named for Jonathan Edwards, a pioneer settler from the early 1800s who lived in a cabin about where East Rookwood Avenue and Edwards Road intersect today. Paxton Avenue is along another Indian trail, and it once led all the way from Hyde Park to Carthage. It is named for Thomas Paxton, a Revolutionary War veteran. Paxton settled in the Loveland area, and he surveyed the road in Hyde Park that bears his name. Linwood originally was laid out as a toll road, with a toll booth at Linwood and Observatory as late as 1904. Madison Road, originally the Madisonville Turnpike, was a toll road as well.

HYDE PARK'S FIRST SETTLEMENTS

In the 1790s, land in today's Hyde Park was valuable for farming. Most of this area in the center of the neighborhood became the property of just five landowners by 1814.

Columbia was principally a farming community, though it was plagued by spring flooding from the Little Miami and the Ohio. This problem led Thomas Wade, an original 1788 settler of Columbia, to buy 160 acres from Symmes on April 1, 1795, which is the land that today is bordered by Observatory Avenue on the south, Wasson Road on the north, Paxton Avenue on the west and St. John Place on the east. In 1796, Ross Crossley bought 120 acres north of present-day Observatory to Madison, bordered by Edwards Road on the east. Two years later, in 1798, another original Columbia settler, Isaac Ferris, bought 200 acres "on the waters of the Duck Creek." This land includes the property between Duck Creek and Madison Road. Today, this land includes the Evanston Playground, Kendall Avenue, Groveland Place, Garden Place, Vista Avenue, Withrow High School and the Regency Condominium tower. Henry Morten, in 1810, bought the land

between Wade and Crossley—the 160 acres between Paxton on the east and Edwards to the west and Observatory to the south and Wasson to the north. Lewis Drake bought another of the 160-acre sections in 1814, bounded by Edwards Road, Markbreit Avenue, Wasson Road and Isabella Avenue. Madison Road was constructed diagonally through this property. In 1815, Henry Morten's son, John, bought 65 acres, south of what currently is the Cincinnati Observatory Center.

Thomas Wade eventually sold his property to James Hey in 1818, and Hey in 1827 built the neighborhood's first estate house, Beau Lieu Hill Farm. (See Chapter 9, The Pines.) Hey changed the 160-acre working farm into a country estate and manor. Beau Lieu, later renamed The Pines by John Kilgour in 1863, remained largely intact until 1919 when much of the land was sold for development. The house and the last eleven acres of the estate remained in private hands until 1965.

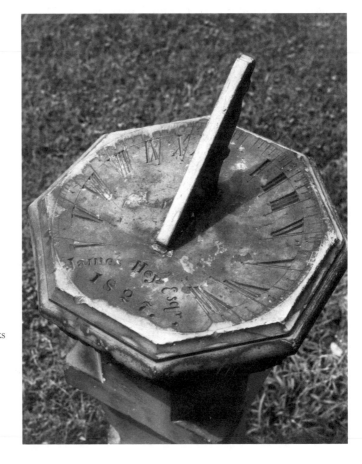

This sundial marks the ownership of Beau Lieu Hill Farm, later renamed The Pines, by James Hey. *Photo by Paul Briol. Courtesy of Mike Judy.*

Most of the original 100- to 160-acre properties that were purchased in the 1790s and early in the nineteenth century were not kept intact once the original owner died. The estate would then be split either among the owner's sons or among all the owner's children, with the result that each child ended up with a portion of what the father had purchased earlier. This was how the heirs of Ross Crossley came to sell land in 1823 to the Committee of the Third School District of Columbia Township for the Mornington School at the northwest corner of City (Observatory) Road and Edwards Road, the site presently occupied by the Hyde Park Elementary School. The Mornington School was unique among schools of that era in that it boasted two rooms rather than the standard one room. It was the Mornington School that gave the name Mornington to the area until about 1887, when it was changed by the members of the Hyde Park Syndicate to Hyde Park.

Henry Morten Jr., who had inherited the eastern half of his father's estate in 1824 (essentially present-day Shaw to Paxton and Wasson to Observatory), bought the 160-acre parcel immediately north of the Hey property, with Wasson the southern boundary, Paxton on the west, St. John Place on the east and near Madison Road on the north—this is essentially today's Hyde Park Plaza and Oakley Playfield.

In 1838, Richard Morten sold his half of the family farm to Robert Shaw, for whom Shaw Avenue was eventually named. Then, in 1843, Henry Morten Jr. (for whom Morten Avenue is named) passed away, leaving his large estate to be partitioned into eleven lots and deeded to his heirs.

The First Grand Estates

Beyond Beau Lieu–The Pines, other large estates were developed, too. Philip Grandin moved to Cincinnati about 1830. In 1835, he built his GrandView mansion along the Indian trail that later would become Grandin Road.

In 1848, Joseph Longworth (1813–1883) and his wife, Annie (1822–1862), were living with his father, Nicholas Longworth (1783–1863), in the family home on Pike Street at Fourth Street downtown. Today, this house is the Taft Museum of Art. Joseph and Annie Longworth decided to strike out on their own that year, and they bought most of the 100-plus acres bounded by Grandin Road on the south, Edwards Road to the east, Observatory Avenue to the north and the large W.W. Scarborough tract to the west. (The Scarborough tract eventually became the Cincinnati Country Club.) There,

Farmland Becomes Mornington

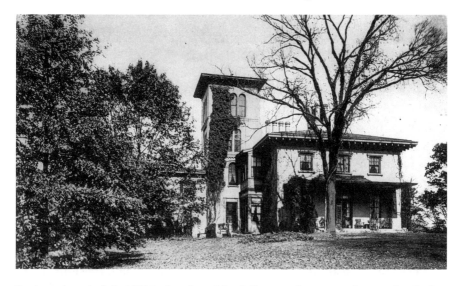

Rookwood was built in 1863 by Joseph and Annie Longworth on more than one hundred acres, abutting Grandin and Edwards Roads. *Courtesy of the Public Library of Cincinnati and Hamilton County.*

Joseph Longworth built Rookwood, named for the large, black birds in the area called rooks. Rookwood[3] would be the Longworth family estate for more than one hundred years. The manor house was built on the highest piece of land on this acreage; the entrance off of Grandin Road today is Rookwood Avenue. Clara Longworth de Chambrun, a granddaughter of Joseph, described the house and area as it existed in 1848:

> *Four miles of rough pike separated town from the small settlement at the corner of Madison and Grandin Roads. In spite of determined efforts to name it Aubrey, the hamlet was originally known as O'Bryonville, or Dutchtown. A lumbering omnibus[4] made a daily journey in and out, obliging passengers for "Rookwood" to cover the last mile on foot. There were, of course, no lamps, but in spite of equal risks from upsets and attacks by highwaymen, it soon became a center of hospitality and good cheer.*

Soon after Rookwood was established, R.H. Harrison built his estate house, Weebetook, on the south side of Grandin Road, on the street today that goes by this name.

HOLY ANGELS, TORRENCE ROAD AND THE PIATT-GRANDIN HOUSE

In 1860, the Holy Angels parish school opened at Madison and Torrence Roads, and in 1861 the Holy Angels cornerstone was blessed by Archbishop Purcell at the same site. Torrence Road was named for George Torrence (1782–1855), a prominent judge on the Hamilton County Court of Common Pleas for twenty-eight years. Torrence Road extended from Eastern Avenue near Saint Rose Catholic Church to Madison Road, parallel and 350 feet to the east of today's Torrence Parkway. The original entrance to Torrence Road on Eastern Avenue (now Riverside Drive) is still there today.[5] Also in 1860, the Piatt-Grandin house was built nearby at the corner of Grandin and Convent Lane for Hannah Piatt, widow of Philip Grandin. Hannah was a descendent of steamboat building captain Benjamin Piatt. It was the Piatts who donated the land for the city's first park, downtown on Eighth Street, known today as Piatt Park.

WASSON ROAD AND COLUMBIA AVENUE

In 1864, Jacob Wasson purchased thirteen acres of what had been Henry Morten Jr.'s land, immediately north of what is today Wasson Road. It was also about this time that Columbia Avenue (which became Columbia Parkway in 1938) was built over the trail that had existed there. Joseph Longworth wanted another access to his home rather than having to go through Walnut Hills to Madison Road or down Eastern Avenue and then up Torrence Road. This new road would also enhance the purchase price of the lots that Longworth was hoping to sell from some of the acreage on the Rookwood estate that he began to subdivide.

WILLIAM GROESBECK AND ELMHURST

Another of the grand country estates was built by William Groesbeck (1815–1897), a noted Cincinnati lawyer who studied law in the office of Salmon P. Chase; he earned a reputation as a brilliant legal mind. Groesbeck was elected as a Democrat to the U.S. House of Representatives in 1856 and he served in the Ohio Senate from 1862 to 1864. His claim to fame was as an important member of the legal team that defended President Andrew

Johnson in his 1868 impeachment trial before the Senate. Groesbeck and his team were successful; the Senate tally fell one vote short of the two-thirds majority necessary to convict the president and remove him from office. Groesbeck returned home and he built his estate, Elmhurst, a three-story, thirty-eight-room mansion on thirty-five acres at the southeast corner of Madison and Grandin Roads, where Elmhurst Avenue is today.[6]

AN EARLY LAND USE DISPUTE

Even in its earliest years, Hyde Park saw battles over land use, and a June 16, 1873 letter to the editor in the *Cincinnati Commercial Tribune* visits one issue concerning a proposed improvement to Grandin Road. The letter is interesting on any number of levels, especially its use of language not generally seen today:

> *To the Editor of the Commercial:*
>
> *My attention has been called to a letter written by an "Afflicted Owner," which was filled with gross misrepresentations, which I am charitable enough to attribute to ignorance rather than willful maliciousness. I regret that he lacked the manliness to sign his own name, as it placed all of his neighbors in an unpleasant position, liable to suspicion, and thereby forcing a number of them to come to me and disclaim its ownership.*
>
> *The Grandin road has been in the city several years, and the original petition for its improvement was signed by owners of a majority of the property abutting upon it. Afterwards another petition requesting its improvement was sent in signed by every property holder except one. The road was in very bad order, and I repeatedly requested the Board of Improvements to permanently improve it by grading and macadamizing. Then no other alternative was left but to follow their directions.*
>
> *The Grandin road will soon be one of the handsomest drives about the city, the scenery more attractive and beautiful than ever to those who wish to drive out there, and which I consider of infinite more value and importance than the destruction of a few trees, some vines and wild flowers, and a few feet of sodding.*
>
> *Geo. M. Hord*

RAIL SERVICE TO MOUNT LOOKOUT

Until trains or streetcars could connect Mornington to downtown Cincinnati, it was impractical to develop Mornington for residential use, as the lumbering horse-drawn omnibuses were insufficiently attractive for large-scale commuting. Development in Mount Lookout occurred much earlier than in Hyde Park because it was connected to downtown by rail. Formerly part of Spencer Township, Mount Lookout was annexed by the city in 1870. John and Charles Kilgour had bought up much of Mount Lookout by the early 1870s. They also were the owners of the Cincinnati and Columbia Street Railroad that ran from the end of the Pendleton horse car line to Columbia. This railroad was completed along Eastern Avenue (then known as Wooster Pike) to Columbia by June 24, 1866. The Kilgours then built the Mount Lookout Dummy—an engine and passenger car all in one—to run from the Cincinnati and Columbia up Crawfish Creek, which is today's Delta Avenue,[7] to provide easy transportation to their property to encourage the sale and development of their Mount Lookout land. Service on the dummy began on July 16, 1872, and continued until 1899.

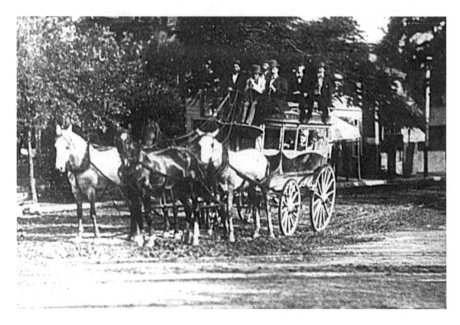

A horse-drawn omnibus from 1873. These were replaced by horse-drawn street cars that later became electrified streetcars, or trollies. *Courtesy of the Public Library of Cincinnati and Hamilton County.*

Farmland Becomes Mornington

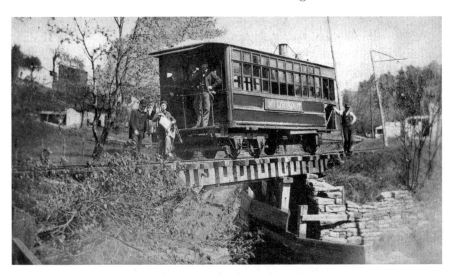

The Mount Lookout Dummy (an engine and passenger car in one) ran along Delta Avenue from just south of Columbia Avenue to Saint John's Park, near the observatory. *Courtesy of the Public Library of Cincinnati and Hamilton County.*

The Kilgour brothers also donated four acres along Observatory Avenue and $10,000 in 1873 to move the observatory from Mount Adams to Hyde Park–Mount Lookout in order to bring attention to their new development. (See Chapter 12, the Cincinnati Observatory Center.) Without similar train access, the development of Mornington would be delayed for twenty years.

ERIE AVENUE

Ohio's General Assembly authorized the construction in 1880 of an improved Erie Avenue, from Madison Road to Paxton Avenue. The road was financed by assessments on all landowners within one mile of the new road, a common financing scheme of the time. Erie was completed from Edwards to Shaw by 1890, and it would be finished from Madison to East Hyde Park beginning in 1893.

THE FIRST CHURCHES

Additional churches besides Holy Angels came to the area by 1880. (The Columbia Baptist Church, which was founded in 1790, later became the

Hyde Park Baptist Church. It was in a number of locations before settling permanently in Hyde Park in 1904.) The Mount Lookout Methodist Episcopal Church, today's Hyde Park Community United Methodist Church, started at the corner of Grace and Observatory Avenues in 1880 on land donated by the Kilgours. The Notre Dame Order bought eight acres in 1881 to establish a convent, and later a school, from the William Groesbeck Elmhurst estate at Grandin Road near Torrence and Madison Roads. The name of the school later was changed to the Summit Country Day School, which has been enlarged to a twenty-three-acre campus.

CINCINNATI AND EASTERN RAILROAD

While the Norfolk and Western Railroad came to Hyde Park in 1872, it was not until 1882 that the Cincinnati and Eastern Railroad truly connected the neighborhood to downtown. The Cincinnati and Eastern's tracks started at

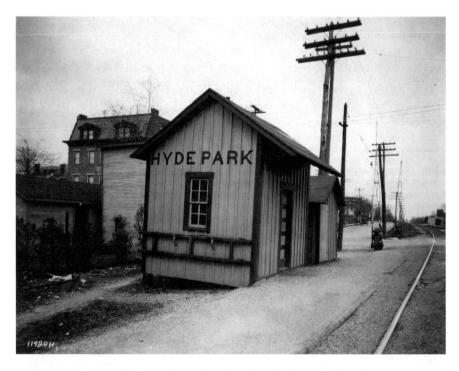

The original Hyde Park train station of the Norfolk and Western Railroad, located near the intersection of Edwards and Wasson Roads. *Courtesy of the Special Collections Department of the Virginia Polytechnic Institute Library and the Norfolk Southern Railroad.*

Court Street and Gilbert Avenue downtown, went up today's Interstate 71 corridor to Norwood and then cut east along the path of today's Wasson Road. These trains made the farmland in Mornington valuable to develop for housing because transportation to downtown was now convenient and available. Before these railroad lines were installed, a traveler from downtown Cincinnati would travel to Mornington by electric trolley to the Saint Francis DeSales Church in Walnut Hills and then either walk the Madisonville Turnpike (then a toll road) or take the occasional omnibus.

The Shaw Farm

In 1883, the Shaw Farm, which ran between Wasson Road to the North, Erie Avenue to the south, Edwards Road to the West and Shaw Avenue to the east, was platted and lots there began to be sold. The properties on either side of Wasson were among the first to be built in present-day Hyde Park and Oakley. The Hyde Park Syndicate would later buy most of this property and resell it.

CHAPTER 3
THE MORNINGTON SYNDICATE BEGETS HYDE PARK

1885–1903

The years 1885 to 1903 arguably were the most important of any period to the development of Hyde Park. The 1882 train connection to downtown had made development of the neighborhood viable, and electric streetcars were brought to the neighborhood soon thereafter. The construction of Erie Avenue, the development of Hyde Park Square and the connections of water, sewer and gas from the City of Cincinnati made the neighborhood ready for residential development. The Mornington neighborhood was recast as Hyde Park in 1887 by the members of the Hyde Park Syndicate, the driving force behind the neighborhood's development. Hyde Park became an independent village in 1896 and was annexed by the city in 1903.

THE MORNINGTON SYNDICATE

In 1885, the Mornington Syndicate was formed by a group that included John Kilgour, Charles Kilgour and James Mooney who had been developing Mount Lookout real estate. The Mornington Syndicate papers are not clear whether there were other members. Mornington, an unincorporated neighborhood within Columbia Township, was the name for what today is Hyde Park, which was taken from the name of the school at the corner of Edwards Road and Observatory Avenue, built in 1823. The Mornington Syndicate purchased two tracts of land inside the triangle bordered by Observatory, Madison and Edwards, but it did not develop these properties.

THE HYDE PARK SYNDICATE

On June 30, 1887, the Hyde Park Syndicate was formed, succeeding to the interests of the Mornington Syndicate. The syndicate members all were successful businessmen even before they embarked on the development of Hyde Park. They were John and Charles Kilgour, James E. Mooney, Albert Berry, Thomas Youtsey, John Zumstein and Wallace Burch.

John Kilgour (1834–1914) and Charles Kilgour (1833–1906) (See Chapter 7, John and Charles Kilgour) owned significant parts of the Cincinnati and Suburban Bell Telephone Company, the Franklin Bank, the Little Miami Railroad, the Cincinnati Street Railway Company and the Miami Machine Company, among other interests. John Kilgour had lived in Hyde Park at The Pines, 3030 Erie Avenue, since 1863.

James E. Mooney (1832–1919) was the principal in several successful leather tanning ventures in Louisville and Indianapolis. He was the principal shareholder in the Mount Adams Incline Plane Railway Company (the Mount Adams Incline), president of the Cincinnati Coffin Company and founder of the American Oak Leather Company. Mooney left an estate in excess of $5 million.

Colonel Albert Seaton Berry (1835–1908), a native Kentuckian, fought for the Confederacy in the Civil War. He graduated from Miami University in Oxford, Ohio, and later from the Cincinnati College of Law. Berry was mayor of Newport, Kentucky, for five terms and he was a United States congressman from Campbell County, Kentucky, from 1893 to 1901. He was descended from General James Taylor, who at one time owned most of the land east of the Licking River in Campbell County. The Taylors and Berrys developed Bellevue and Dayton, Kentucky.

Thomas B. Youtsey (1843–1915) was a Newport banker and an associate of Berry's. At the time the Hyde Park Syndicate was founded in 1887, Youtsey was the cashier for the First National Bank of Newport, Kentucky. He ran into financial difficulties, however, and his share of the Hyde Park Syndicate was sold to Henry Burkhold on January 18, 1897, to satisfy Youtsey's creditors. Burkhold was the president of the Luhrig Coal Company, which mined, shipped and supplied coal for home heating use, and he had an interest in I&E Greenwald Co., a manufacturer of steam engines, mill gearing, boilers, transmission machinery and complete power plants. He built a house at 2530 Erie Avenue in 1912 that still stands today.

John Zumstein (1826–1907) was born in Bavaria and immigrated to Philadelphia in 1845. He apprenticed as a butcher there and moved in 1848

to Cincinnati, where he continued to work as a butcher and eventually owned his own meatpacking business. A Republican, Zumstein was elected state legislator, county commissioner and county treasurer. In 1892, President Benjamin Harrison appointed him postmaster.

Wallace Burch (1857–1914) was born in Kentucky and grew up in Maineville, Ohio. He graduated from Ohio Wesleyan and later from the Cincinnati College of Law. He was a prominent lawyer, and he was a partner with Simeon Johnson[8] in the law firm of Burch and Johnson. Burch was the personal lawyer for John and Charles Kilgour, and both Burch and Johnson performed legal work for the syndicate.

Mooney Avenue, Zumstein Avenue, Berry Avenue, Burch Avenue, Kilgour Avenue, St. Charles Place and St. John Place all are named for syndicate members. The names of St. Charles and St. John were given in joking fashion. John Kilgour named St. Charles for his older brother, who returned the favor with St. John several years later.

A number of historical descriptions of the Mornington Syndicate incorrectly place its start in 1892 and say that the Mornington and Hyde Park Syndicates were the same organization. A court case from 1893, *Cobb v. Bohm*,[9] describes the Mornington Syndicate as entering into sales contracts for land in 1885. The Mornington Syndicate papers are unclear about who its original members were, but it is evident from 1909 trial testimony given by Wallace Burch that at least John Kilgour, Charles Kilgour, James Mooney and probably Albert Berry participated.

What is clear from the files of the Hyde Park Syndicate is that this new syndicate took over the interests of the Mornington Syndicate, and that it started on June 30, 1887, with the Kilgour brothers, Berry, Mooney and Youtsey each having one share, and Zumstein and Burch each having a one-half share.[10] Everyone but Burch paid cash; Burch was to earn his share by doing legal work for the syndicate, engaging in the purchase and sale of land contracts that the syndicate envisioned.

The sales contracts that the syndicate would enter into had five restrictive covenants that describe the type of neighborhood the syndicate members envisioned:

> 1. *Each building shall be placed at least 40 feet from the street line;*
> 2. *Each residence shall cost not less than $3,000;*
> 3. *Each property shall be used exclusively for residential purposes;*
> 4. *No outbuildings, including no stables were to be built on the property and*
> 5. *No spiritous or malt liquors could ever be sold on the property conveyed.*[11]

The lots generally were sold in dimensions of 50 feet by 150 feet. The condition prohibiting outbuildings was later modified to allow automobile garages.

The Hyde Park Syndicate gradually acquired property, developed roads and worked with the city to connect the neighborhood to city water, gas and sewer utilities. John Kilgour was president of the Cincinnati Street Railway Company, and he had streetcar service extended on Madison Road from Saint Francis de Sales Church in East Walnut Hills to Hyde Park along Erie Avenue. Erie Avenue was an old country road; it received its name in 1872 after Lake Erie at the urging of the Kilgour brothers, who also were investors in the Miami and Erie Canal connecting the Ohio River at Cincinnati to Lake Erie near Toledo.

It took several years, but the syndicate bought almost the entire triangle created by Observatory Avenue, Madison and Edwards Roads, as well as a large stretch of ground to the east of Edwards Road, for $400,000.[12] John and Charles Kilgour owned most of the land to the east of the syndicate property, north of Observatory Avenue. In connection with the sales process, the syndicate members changed the name of the neighborhood from Mornington to Hyde Park in 1887, borrowing from the name of the elegant Hudson River town, consistent with their grand designs for the neighborhood.

The syndicate hired Tilden R. French in 1892 as its manager, and a "descriptive talk" he placed in the May 24, 1892 *Cincinnati Commercial Gazette* gives the reader the thought in mind behind the future development of the neighborhood.

In slightly purple prose, French wrote that:

> *"Hyde Park" is by right of endowment...Clifton's[13] natural rival. And it possesses that which the Cliftonites never experienced—cheapness of cost.*
>
> *When we consider that this garden portion of East Walnut Hills may be purchased at a low price, considering its unrivaled advantages, then the observer ceases to wonder at the unprecedented sales in this peerless subdivision now popularly known as "Hyde Park, ideal suburb."*
>
> *Hundreds of people visit Hyde Park every clear day. On Sunday the cable cars are crowded with visitors who find pleasure in contemplating the manifold advantages of this great estate and who unanimously are of the opinion that it is a fine property.*
>
> *The [cable] car enters the park from the Madison pike, and glides rapidly through the grounds. A first glance at the splendid real estate is sufficient to arouse the admiration of the visitor, and the sense of wonder is natural that so eligible and splendid real estate was not placed on the*

market before this year, while all around it private properties bearing residences of palatial splendor are seen. But the visitor is satisfied when informed that an outlay of fully $400,000 was required to place the grounds in its present condition.

Home-like edifices are springing up on every side. Hyde Park constitutes a portion of East Walnut Hills and lies between Mt. Lookout, Ivanhoe[14] and the City's northeastern limits. It is on a high plateau. The great fertile valleys of Mill Creek and Duck Creek lie spread out, a scene of surpassing loveliness, with the great amphitheater of the wooden hills inclosing the smiling surface of the fields threaded with streams of water. Visitors to Hyde Park in any season go into raptures over the scenic embellishments.

John Stettinius says of Hyde Park "that it is a most admirable suburb and an excellent place for nice homes. Hyde Park has a great future, it is healthful, picturesque, easy of access and just the place for wives and children."

Home building began in earnest but it did not occur all at once. The streets were built out gradually, with the first of the houses in the original Hyde Park triangle dating to about 1890, although few were built before 1895. Myers Y. Cooper (See Chapter 8, Myers Y. Cooper: The Home Builder) came to Hyde Park in 1894 and he quickly gained the trust of the Kilgours and the other syndicate members. His Myers Y. Cooper Company took over the construction for most of the syndicate properties, but this building process would take many years.

OTHER DEVELOPMENTS

The syndicate members were not the only ones to get in on the development action. Colonel W.A. "Policy Bill" Smith owned a house on five acres at 2880 Linwood Avenue and an additional piece of land that he subdivided into thirty-eight building lots on the triangle south of Observatory and bounded by Linwood Avenue and the newly built Monteith Place. This land was auctioned off beginning September 22, 1896, and its development started immediately thereafter. The Henry Cordes subdivision in the 3400 block of Monteith, between Observatory and Erie, also was built out during these years. Lots in the Cordes subdivision are smaller than the syndicate lots, and they range from 32 by 125 feet to 50 by 125 feet. The portion of the 3500 block of Monteith south of Ziegle Avenue was built out in these years

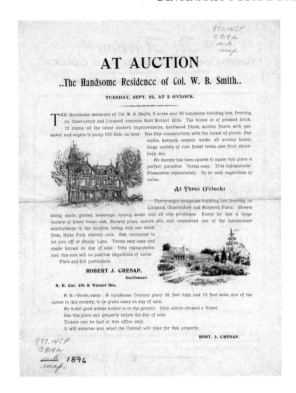

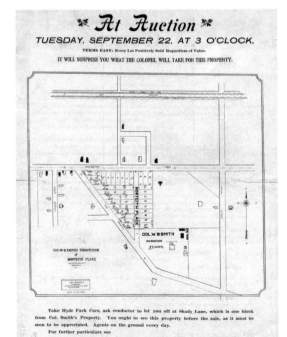

This page: The land sold at this auction principally became the 3300 block of Monteith Avenue. The house was later damaged by the 1917 tornado. *Courtesy of the Cincinnati Museum Center–Cincinnati Historical Society Library.*

in the Myers Y. Cooper subdivision by Cooper. Also, Cooper built out the 3500 block of Mooney Avenue during this period, which is both the Hyde Park subdivision and the Kinney subdivision.

CHURCH DEVELOPMENT

With more people moving to Hyde Park, more churches started as well. (See Chapter 13, Churches of Hyde Park.) The Duck Creek Baptist Church, later to become the Hyde Park Baptist Church, was meeting in Mount Lookout. Knox Presbyterian met on the second floor of a feed store on Wabash (now Griffiths) Avenue in 1895 before moving in 1896 to its new home at the northeast corner of Erie and Shaw. Saint Mary Catholic Church started meeting in 1898 in the Wabash Avenue feed store, where Knox got its start three years earlier. Parishioner Nicholas Walsh, who built his mansion Belcamp in 1900, donated three lots at Erie and Shady Lane in 1901 to build Saint Mary's a sanctuary.

THE COLUMBIAN AVENUE CONTROVERSY

October of 1893 saw another of Hyde Park's land-use battles, but the Columbian Avenue dispute was of a different character than the others. Erie Avenue was not finished on the east past Paxton Avenue. The Hyde Park Syndicate had persuaded the Ohio General Assembly to approve appropriation for a new street to be called Columbian Avenue,[15] which would run on a diagonal line from the intersection of Linwood and Paxton up to the current site of Erie Avenue and proceed east, as shown on the map reproduced from the October 9, 1893 *Commercial Tribune*. Public opinion was incensed both that the road ran through the Kilgour farms, making them more valuable for development, but also at the perceived high cost the state would pay landowners—including the Kilgours—for the land to build the road. Most of Columbian Avenue was built in the next few years, though it was built as a direct extension of Erie Avenue east from Hyde Park Square rather than on the diagonal line from Linwood Avenue.

The *Tribune* also railed against public monies to improve existing Erie Avenue. On October 9, 1893, the *Tribune* wrote that:

> *Here is a diagram of the Kilgour roads: Erie avenue, that nice little one-hundred-and-sixty-foot boulevard in Hyde Park, which is to be paved*

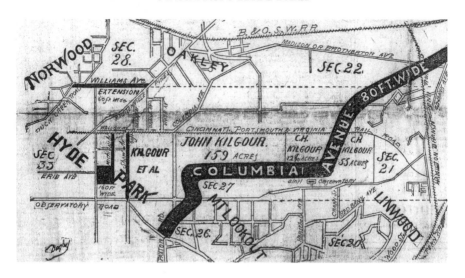

October 9, 1893 map illustrating the Columbian Avenue controversy. Note the changed street names of several streets—today's Hyde Park Avenue was then Oakley Avenue. *Courtesy of the* Commercial Tribune.

with the best vitrified brick by the trustees of Columbia Township at the taxpayers' expense, is shown [in the map reproduced here]. *This elegant road, 160 feet wide and one square long, from Edwards road to Michigan avenue, should be christened by the delighted taxpayers, who foot the bill, Kilgour Esplanade, but it is very doubtful whether a Tyler Davidson can be found among them who will erect a fountain for the delectation of the sojourners in Hyde Park, or a monument to the memory of the county's benefactor.*

How the members of this Hyde Park syndicate, of which the Kilgours, John and Charles, are the head and front, have been counting on this improvement is well illustrated by the fact that they have at present under way, and in fact nearly completed, an elegant apartment house at the corner of Edwards road and Erie avenue fronting this brickyard which it is desired to promote at the expense of Columbia Township.

The article's Tyler Davidson reference is to the statue the *Genius of Water* on downtown's Fountain Square. Henry Probasco gave this fountain to "The People of Cincinnati" in honor of his brother-in-law, Tyler Davidson. As a peace offering, Charles Kilgour gave to "The People of Hyde Park" the Kilgour Fountain on Hyde Park Square, which was dedicated November 6, 1900, where it remains today.

THE SHAW MASTODON

One of the more remarkable discoveries during these years occurred on June 4, 1894. Louise Shaw owned the land north of Observatory and east of Edwards on the site of what now is the Knox Presbyterian Church. She paid laborers to dig a cistern for her, and that day they came across what eventually was determined by members of the Cincinnati Historical Society to be fragments of bones and tusks of three mastodons. These mastodons were not the only local such discovery. Remains of other mastodons were also found in what today is Big Bone Lick State Park in northern Kentucky. Meriwether Lewis traversed this area in 1804 on his way to meet up with William Clark. He took a mastodon bone from this Kentucky site, and upon his return to Washington after the Lewis and Clark expedition, presented it to President Jefferson. That bone can be seen today displayed in the foyer of Jefferson's home, Monticello.

HERMITAGE AND BELCAMP ESTATES

Two of Hyde Park's grand estates, the Hermitage and Belcamp, were built during this period.

The Hermitage was built in 1891 by Lucien Wulsin Sr. (1845–1912), a founder with Dwight Baldwin of the Baldwin Piano Company. Wulsin's home sat on twenty-eight acres at the corner of what is today Dana Avenue and Madison Road. The house originally was built by John Ferris Jr. about 1840. A resident previous to Wulsin had lived in the house alone, as a hermit, thus providing the house's name. Wulsin and his wife, Katherine, leased the house in 1888 and bought it in 1891. The Wulsins substantially enlarged the house in 1892 and made it into one of the great Hyde Park mansions, along with The Pines, Rookwood, Elmhurst and Weebetook. Wulsin had served in the Union army during the Civil War, took great pride in his service and hosted annual reunions of his regiment at his manor house. Wulsin also played a leading role on the Cincinnati Park Board and donated the land to the board for the Wulsin Triangle at Madison on the north side of Observatory.

Belcamp was also built during this period, in 1900, by Nicholas Walsh Sr. (1855–1915). It was the last grand Hyde Park showpiece estate to be constructed. The driveway was along the current Walsh Avenue off of Edwards Road. The estate was more than 150 acres, fronted by Linwood, Paxton and Delta Avenues and Grandin Road. Walsh was president of the

Walsh Distillery of Lawrenceburg, Indiana, which was started by his father, James. Walsh died in 1915, leaving an estate of more than $2 million. In 1917, his widow, Susanna Walsh, sold the distillery and married Fredrick Wallis Hinkle. Mr. Hinkle died in 1950 and Mrs. Hinkle died in 1952.

HYDE PARK SQUARE

Hyde Park Square, originally the Kilgour Esplanade, was laid out during this 1885–1903 time period. (See Chapter 10, Hyde Park Square.) The Burch Flats (today the Mills Judy Building), at the northeast corner of Erie and Edwards, was built in 1890. The fountain and center boulevard were donated by the Kilgours, and the first version of the park was complete in 1900. The Al' Aise apartments at the southeast corner of Erie and Edwards were built in 1903. The square originally was home to both dwellings and to retail. Sanborn fire maps from 1903 show that there were also three buildings on the square devoted to "moving pictures." Other buildings were also built along the square during this period, but they were torn down later to make room for the buildings that are present today.

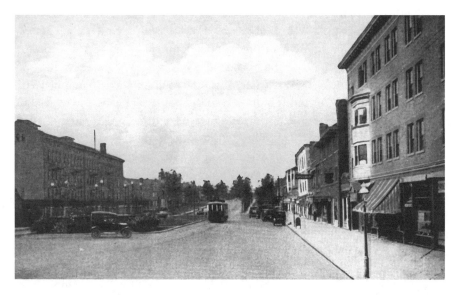

This picture of the square likely was taken sometime between 1922 and 1926. Note the trolley headed west on Erie Avenue. *Courtesy of the Public Library of Cincinnati and Hamilton County.*

THE VILLAGE OF HYDE PARK

Hyde Park became populated enough that it was incorporated as a village on June 22, 1896. Louis Ziegle was Hyde Park's first mayor. Ziegle ran on a ticket with a slate of candidates; one statement in their campaign literature was that:

> *With wise legislation, Hyde Park, with the advantages of location and surroundings, will become in time, the Banner Village of Hamilton County; and to this end we pledge our very best efforts to which we have been nominated by the citizens at large.*

Ziegle bested Lucien Wulsin Sr. in the mayoral election. He later was succeeded to the mayoralty by G.F. Osler and William McCormick. The Hyde Park Town Hall was built in 1901 at the northeast corner of Erie and Michigan Avenues, with village offices, meeting spaces and a jail. Hyde Park does not see much crime today and it saw even less back then. The jail was used but once to house a nonresident for disorderly conduct. The Hyde Park Elementary School, at the corner of Edwards and Observatory, was dedicated on May 22, 1902, for the youth of the neighborhood.

ANNEXATION BY THE CITY OF CINCINNATI

The brief life of an independent Hyde Park came to an end on November 17, 1903, upon the motion of homebuilder Myers Y. Cooper. The village residents voted that day to be annexed to Cincinnati.

CHAPTER 4
OLD AND NEW PLANS TAKE SHAPE

1904–1929

The years 1904 through 1929—the first years of Hyde Park as a neighborhood in the City of Cincinnati—saw the completion of the first phase of Hyde Park planned by the Hyde Park Syndicate back in the 1890s. It also saw the deaths of all seven members of the group. Bayard Kilgour Sr. started to sell off parts of the 156-acre The Pines property for development after the 1914 death of his father, John Kilgour. Other landowners decided to get in on the action, and they planned new streets and subdivisions for the second round of development that began in earnest during these years. The neighborhood had to recover from disaster after the March 11, 1917 tornado damaged or destroyed more than one hundred houses. The increased population put stress on the physical facilities of schools and churches, and these grew in response.

THE LITTLE MIAMI RAILROAD'S TORRENCE STATION

The Little Miami Railroad was completed from downtown along Eastern Avenue to the Little Miami River, then north to Springfield, in the 1840s. (See Chapter 7, John and Charles Kilgour: The Money and the Vision Behind Hyde Park.) It had been operated by the Pennsylvania Railroad since 1869. With the burgeoning Hyde Park population in the early twentieth century, in 1907, the Pennsylvania built a station on Riverside Drive (then Eastern Avenue) at Torrence Road near Saint Rose Catholic Church. The Torrence

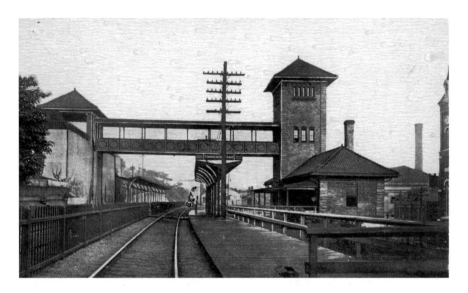

The Torrence Road station in 1910 off of what is today Riverside Drive. Parts of the two towers are still visible today. Note Saint Rose church on the very right. *Courtesy of the Public Library of Cincinnati and Hamilton County.*

Station was called one of the Pennsylvania's finest. That station stayed in operation until March 31, 1933, when Union Terminal opened. Parts of the Torrence Station are still visible today on the north side of Riverside Drive at Torrence Road.

SYNDICATE LAND DEVELOPMENT AND KINNEY FARM

Myers Y. Cooper built the homes on most of the lands of the Hyde Park Syndicate in the original triangle bordered by Madison, Observatory and Edwards. He built most of the houses on the 3400 blocks (between Erie and Observatory) of Berry, Stettinius, Burch, Mooney and Zumstein between 1904 and 1921. The 3500 blocks (between Erie and Madison) of these streets—which also contained the land of the Kinney Farm—also were largely completed during these years. Cooper also built on a number of tracts he purchased. Cooper bought the Erdhouse tract from the syndicate in 1914, built Kendall Avenue and Groveland Place on this property and proceeded to build the homes on these streets. That same year he bought the Ben-Ve-Nuto tract from S.B. Sachs, later constructed Ziegle, Outlook, upper Monteith (the portion that parallels Outlook) and the western portion

Old and New Plans Take Shape

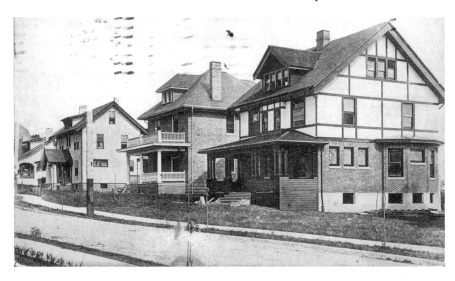

Myers Y. Cooper built many, if not most, of the homes in Hyde Park before 1929, including these homes on Victoria Avenue. *Courtesy of the Public Library of Cincinnati and Hamilton County.*

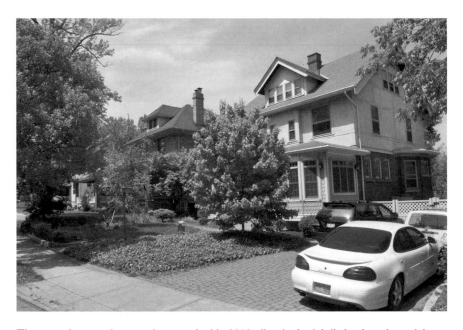

These are the same houses, photographed in 2010, disguised mightily by the substantial trees. *Courtesy of the author.*

of Victoria Avenue, and then he built most of the houses on these lots.[16] The houses on St. Charles Place also were built principally between 1905 and 1920.

The syndicate finally reached an end on March 16, 1920, with the sale of its final lots and payment of its last dividends. It reported contributions of $38,034.26 by each whole share and dividends per share of $33,784.46. What is not reported are the presumably substantial interest payments made by the syndicate to its members over its thirty-three-year history.

Its attorney, Rufus B. Smith, summarized the syndicate's history in a 1911 Ohio Supreme Court brief as follows:

> *By an agreement entered into the thirtieth day of June, 1887, James E. Mooney, T.B. Youtsey, A.S. Berry, C.H. Kilgour, John Kilgour, John Zumstein and Wallace Burch entered into a written agreement for the purchase and sale of land. The agreement is what is known as a "land syndicate" agreement.*
>
> *The syndicate has been in operation ever since the agreement was signed, and is still in operation. Like most enterprises of this character it has taken*

This is a 1920 letter to the members of the Hyde Park Syndicate, wrapping up the business started in 1887. The last original syndicate members passed away in 1919. *Courtesy of the Cincinnati Museum Center–Cincinnati Historical Society Library.*

far more time to sell the land than it was thought possible at the time the syndicate was formed.[17]

STETTINIUS LAND DEVELOPMENT AND NILES FARM

Barnabas Niles died in 1844, leaving an estate of 106 2/3 acres of farmland that bordered Observatory to the north, Edwards to the east, the fence separating Menlo Avenue from the Cincinnati Country Club to the west and a line near West Rookwood Court to the south. Niles's ten heirs split the land into eleven lots, each taking one, but they jointly kept the lot of 12 acres at the corner of Edwards and Observatory.

In 1863, John Longworth Stettinius (1832–1904) purchased fifteen acres of this property that fronted Observatory and a narrow road off of Observatory to the south, established in 1844, that became Stettinius Avenue. Stettinius built his three-story limestone house along this road and called it Oatfield. He bought ten additional acres in 1872 along Edwards Road and six acres from his uncle Joseph Longworth's Rookwood properties to the south. This left Stettinius owning an *L*-shaped property of thirty-one acres surrounding what was left of the Niles Farm at the corner of Edwards and Observatory.

Looking east on Grandin Road. *Courtesy of the Public Library of Cincinnati and Hamilton County.*

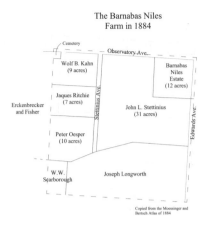

The Barnabas Niles Farm in 1884

Copied from the Moessinger and Bertsch Atlas of 1884

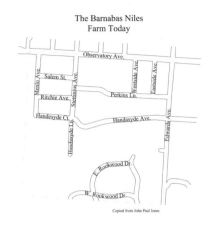

The Barnabas Niles Farm Today

Copied from John Paul Jones

Courtesy of Roger F. Weber.

Stettinius's grandfather was the first Nicholas Longworth, who arrived in Cincinnati in 1803. Longworth's daughter Mary (1808–1837) married John Stettinius (1805–1835), who was reputed to be the first white child born in Washington, D.C. Their son, John Longworth Stettinius, was orphaned at the age of five, and he lived in his grandfather's house at Pike and Fourth Streets downtown, the house that today is the Taft Museum of Art. Stettinius spent his time managing his real estate and working on charitable causes, especially including the Cincinnati Children's Home, of which he was president for twenty-five years and where he spent much of his time. He had two children, Henry Stettinius[18] (1859–1916) and Mary Longworth Stettinius Perkins (1857–1931).

The Niles heirs subdivided the Edwards–Observatory corner property in 1900 and houses were built along Eastside, Westside and Southside (later Roseland) Avenues, principally between 1905 and 1921. Stettinius's daughter, Mary Longworth Stettinius Perkins, lived in Oatfield after her father's 1904 death and started subdividing this estate. In 1910, she sold the Observatory frontage for four lots to Joseph Carew, E.W. Edwards, Rosa Rendigs and Jessie Pape. These properties remain intact today at 2531, 2555, 2561 and 2567 Observatory. Mary Perkins established Handasyde[19] Avenue as a private drive in 1922, named for her late husband, James Handasyd Perkins Jr.,[20] although most of the homes on this street were not built until the 1930s. Roseland Avenue became Perkins Lane in 1951. The Niles Farm property and the Stettinius property all are in the Niles subdivision.

The houses along the 3300 block of Stettinius (south of Observatory), Ritchie Avenue (named for Jacques Ritchie, who owned the land at one point) and Menlo Avenue are all in the Menlo subdivision. While some of these houses were built before 1904, most were built from 1904 to 1924.

DEVELOPMENT OF SHAW FARM

The Shaw Farm, known on property records as the Anthony Weber subdivision, is between Shaw and Michigan, Wasson and Erie, and it includes Wabash (later Griffiths) Avenue. Wabash Avenue was changed to Griffiths after the city's 1903 annexation of Hyde Park, for the city already had a Wabash Avenue prior to the annexation. Homes in the 3500 block of Michigan between Griffiths and Erie were built principally between 1908 and 1915. The 3600 block of Michigan, north of Griffiths, which also is on the old Shaw Farm, was developed between 1905 and 1911.

PLANS FOR THE DEVELOPMENT OF KILGOUR ACRES

John Kilgour owned The Pines from 1863 until his death in 1914, and he kept his 156-acre property largely intact during this period. (See Chapter 9, The Pines.) Within about five years of Kilgour's death, his son, Bayard Kilgour Sr., sold to Myers Y. Cooper all of the remaining property of The Pines except for 11 acres and the estate house where Kilgour's widow, Mary, lived until she passed away in 1919; Bayard moved his family into The Pines after his mother's death. Cooper and others built the homes on the 3400 block of Paxton and Grace (between Erie and Observatory) and the houses along Erie and Observatory between Delta and Paxton.

Cooper then undertook to build Kilgour Acres—the name is seen today on the stone pillars at Bayard and Erie—and he platted Raymar Boulevard and Avenue in 1923, Bayard Avenue and Portsmouth Avenue in 1926 and Victoria Lane in 1928. These homes in Kilgour Acres were designed to be a step above most of the earlier homes that Cooper had built and on larger lots than the standard 50-foot by 150-foot lot found in much of Hyde Park.

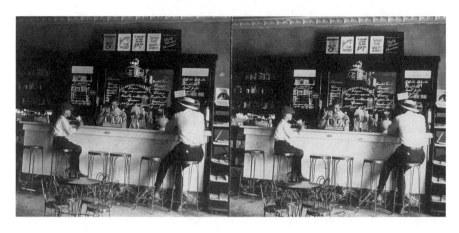

Interior of Weik's Pharmacy, circa 1917–1918. *Courtesy of Tom Compton.*

OTHER DEVELOPMENT

Besides the construction of many houses from 1904 to 1925, the development of streets and the completion of Hyde Park Square, other development occurred during this period, especially around the periphery of Hyde Park.

In 1904, the O.M. Mitchel building was finished at the observatory. (See Chapter 12, the Cincinnati Observatory Center.) This building houses the 1843 telescope purchased by Mitchel for the original observatory in Mount Adams.

In 1911, Levi Ault made the first of his many donations of land for the 224-acre park that became known as Ault Park. (See Chapter 11, Ault Park.) The dedication of the pavilion would not occur until 1930, however, and even then the park was not finished. The original entrance to the park was by way of Principio Avenue, a road John Kilgour constructed in the 1870s after he bought the land from I.D. Wheeler, a hermit who lived on the property. Kilgour spent many years convincing Wheeler to sell.

An Albers grocery store was built in 1921 at 2675 Madison Road (now home to Busken Bakery). This was a much bigger grocery than the ones found on Hyde Park Square; unlike the retail in the square, this store had ample parking.

COMPLETION OF BUILDINGS AROUND HYDE PARK SQUARE

Hyde Park Square as it appears today was completed by 1929 with the exception of 2721 Erie on the south side of the square, which was built in

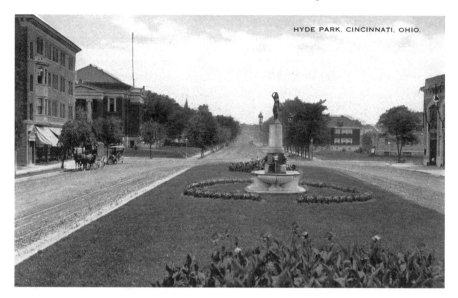

Hyde Park Square, taken sometime between 1912 and 1926. *Courtesy of the Public Library of Cincinnati and Hamilton County.*

1932. Retail in the square was much more suited to a walking neighborhood than the specialty shops found there today. Small groceries, meat markets, flower markets, druggists and drycleaners were prevalent. (See Chapter 10, Hyde Park Square.) The park in the middle of the square was raised from street level to its current height in 1926.

The Hyde Park Branch Library opened in August of 1912, a gift to the city by Andrew Carnegie (1835–1919). This library was the 279th built by Carnegie in his effort to give away his fortune following his 1901 sale of Carnegie Steel to J.P. Morgan, who formed U.S. Steel. The original building was sixty-four feet by sixty-nine feet, and it was designed as a traditional Carnegie library, much different than the library's appearance today after the 1970 expansion and renovation of the building. The library opened with 6,000 books, of which 2,500 were in the children's department. The basement was dominated by a 252-seat auditorium.

Just off the square, the Hyde Park Town Hall was sold by the city to the Hyde Park Masonic Lodge on December 22, 1915, for $13,250. The Masons had been the principal tenant in the building since the city's 1903 annexation of the Village of Hyde Park.

Also in 1915, the La Tosca Flats at 2700 Observatory Avenue, at the northeast corner at Edwards, were built. This nine-unit apartment

building was placed on the National Register of Historic Places in 1999. The December 18, 1998 application for La Tosca Flats to be placed on the National Register observed that:

> *Freestanding six- to nine-unit buildings such as La Tosca were built in large numbers in Hyde Park, and throughout the city as a whole, in the 1900s, 10s and 20s.*
>
> *Relatively compact in footprint, six-unit buildings were well adapted for smaller urban lots. In neighborhood business districts, they often included shopfronts. The Peebles Flats at 2727 Erie (1910s) and the Sibcy Flats (1920s) on Madison Road are examples of six-unit buildings; the former, built on Hyde Park Square, includes twin storefronts, with the main entrance centered between them.*
>
> *On larger parcels of land, generally on main thoroughfares, builders built larger, more imposing structures in the 1910s and 20s.*
>
> *Regardless of form or size, Hyde Park's apartment buildings were scaled to their domestic context; a neighborhood made up primarily of one- and two-story dwellings. Thus they differ from the tall buildings built in the central business district, where high property values dictated more intensive use of land.*

One of the promises the promoters of annexation of the village by the city had made was establishment of a paid fire company. Hose Company Forty-six was formed in a carriage house at the corner of Griffiths and Michigan Avenues. The Hyde Park Syndicate donated land to the city on the square for the new firehouse on April 2, 1907.

The Hyde Park Firehouse was completed on April 30, 1908, and it was dedicated on July 18, 1908, thus completing the four corner buildings on Hyde Park Square. A grand celebration attended the dedication, and this was the event that caused the Hyde Park Business Association to publish its pamphlet *Hyde Park In Its Glory: A Historical Sketch* that contains a marvelous description of turn-of-the-century Hyde Park. Today, the firehouse is home to Engine Company Forty-six, formerly Hose Company Forty-six.

GROWTH OF THE CHURCHES

Hyde Park has always seen a relatively great number of churches compared with its population. The years 1904 to 1929 saw significant growth of the original churches and the building of several grand, limestone structures still in use today.

Old and New Plans Take Shape

Saint Mary Catholic Church constructed its first sanctuary, a red brick structure, in 1903 on Shady Lane using land donated by Nicholas Walsh. (See Chapter 13, Churches of Hyde Park.) The church's congregation grew quickly in these early years, and Saint Mary was able to raise the funds for and construct the marvelous Gothic sanctuary still present today; Archbishop Moeller dedicated the structure on December 9, 1917.

In 1904, the Hyde Park Baptist Church (which originated in 1790 as the Columbia Baptist Church) decided to move from Mount Lookout to Hyde Park. The first part of its church building was completed at the southeast corner of Erie and Michigan in 1907 on land donated by the Hyde Park Syndicate. The balance of the building along Michigan Avenue was completed in 1926.

The Episcopal Church of the Redeemer started meeting in 1908 in the Hyde Park Town Hall. The congregation built its own church building that was finished in 1916 at 3443 Edwards Road, just north of the Hyde Park Elementary School. Redeemer would stay at this location for forty-seven years.

The Mount Lookout Methodist Episcopal Church suffered a schism in 1907, and the group that broke off became the Hyde Park Methodist Episcopal Church. They built their church building in 1915 at 2753 Erie Avenue, on the south side of Erie, that today houses doctors' offices. The two churches reunited in 1922 to become the Hyde Park Community United Methodist Church, which in 1927 completed the handsome Gothic sanctuary at the corner of Grace and Observatory. The Hyde Park ME church building on Erie Avenue was sold to the Hyde Park Evangelical United Brethren, who met at 2753 Erie from 1924 to 1959.

Holy Angels Catholic Church had been established in 1861 on what now is the top end of Torrence Parkway. Senator Joseph B. Foraker passed away in 1917, leaving his estate house at the northeast corner of Grandin and Madison Roads. Holy Angels purchased this property for its new church in 1920.

Knox Presbyterian Church had been located at the northeast corner of Shaw and Erie Avenues since 1895 in the church building—minus the steeple—that remains today. This congregation had outgrown its original building, and it built a new sanctuary beginning in 1928 at 3400 Michigan Avenue (on top of the site where the Shaw Mastodon was found in 1894). This building was dedicated on May 26, 1929.

THE BUILDING OF SCHOOLS

With the growing Hyde Park population from 1904 to 1929, the need for more schools arose as well. (See Chapter 14, Hyde Park Schools.) Hyde Park Elementary School had been dedicated in 1902, but it ran out of room as Hyde Park grew.

In 1908, Saint Mary parish opened its grade school in the red brick church building on Shady Lane. (This building is no longer standing today.) The parish opened Saint Mary High School in 1923 for both boys and girls in the school building that today is Saint Mary School. The high school became a girls-only school in 1927 when the boys left for the new Purcell High School in East Walnut Hills.

The Cincinnati Board of Education opened East High School in 1919 on Madison Road, serving virtually the entire eastern portion of the city, including Hyde Park, Mount Lookout, Mount Washington, Oakley, Madisonville and Bond Hill. The school was renamed Withrow High School in 1924 after John M. Withrow, a longtime member of the board of education.

Hyde Park Elementary School filled up quickly, serving students from Mount Lookout and Hyde Park and Oakley. In part to alleviate this problem, Mary Kilgour, the widow of John Kilgour, was asked to donate land she owned on Herschel Avenue (property that is arguably in Mount Lookout), and she did so in 1914. The John C. Kilgour school, open to students from kindergarten to sixth grade, was dedicated in 1922. Hyde Park Elementary School needed more space even after Kilgour was opened, and Hyde Park added its two-story addition along Observatory Avenue in 1927. Demand for Kilgour was so high that it was expanded in 1928, and it has seen several additions in the ensuing years.

Further demand for education in Catholic schools continued as well. In 1927, the Academy of Our Lady renamed itself the Summit. Holy Angels opened its elementary school in 1929 at the northeast corner of Grandin Road and Madison Road, next to the parish church that had been built earlier in the 1920s. This school does not remain today—it was located on the playfield at that corner, next to the Springer School.

THE HYDE PARK TORNADO

March 11, 1917

At about 7:30 p.m. on March 11, 1917, a tornado with seventy-five mile per hour winds tore through Hyde Park, Mount Lookout, O'Bryonville and Linwood. The tornado damaged or destroyed more than one hundred homes[21] and took three lives. It was about a quarter-mile in width, making its way through Hyde Park on the southern side of Observatory Avenue, touching down east of Michigan Avenue and leaving Hyde Park just east of Herschel Avenue. The tornado caused more than $500,000 in property damage, which equals about $8 million in 2010 dollars. The cyclone was the first recorded in Cincinnati history.

A committee of James Gregson (Gregson Place), park commissioner Irwin Krohn (Krohn Conservatory), homebuilder Myers Y. Cooper, Michael Keefe, Councilman Charles Rose, Dr. S.R. Teasdale, Arthur Behymer, William Lambert, George Thompson, George Mills and A.B. Dunlap

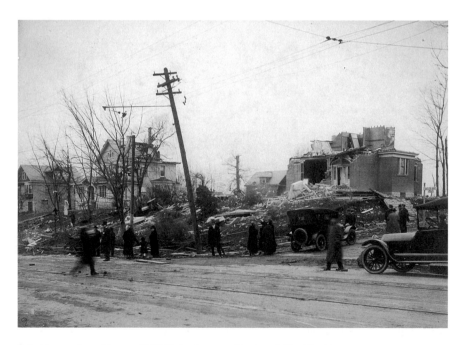

Scheidemantle residence, 1323 Delta Avenue. *Courtesy of Tom Compton.*

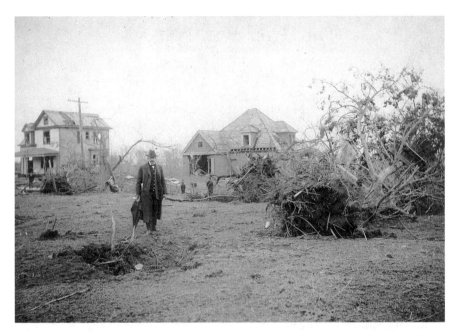

The aftermath of the March 11, 1917 tornado. The house in the center is 1354 Herschel Avenue. The picture is taken from what is today the Kilgour School. *Courtesy of Tom Compton.*

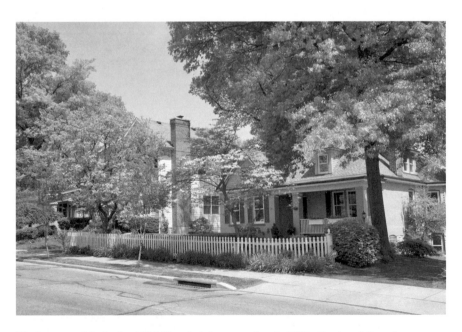

The house at right is also 1354 Herschel Avenue, taken in 2010. *Courtesy of the author.*

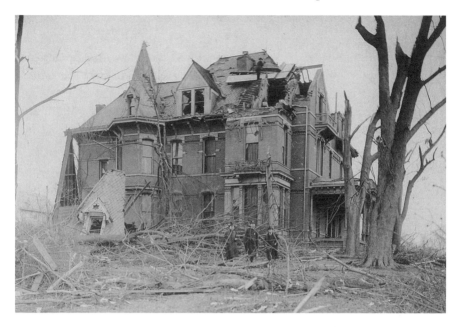

Kessing residence, formerly the home of Policy Bill Smith, auctioned in 1896. *Courtesy of Tom Compton.*

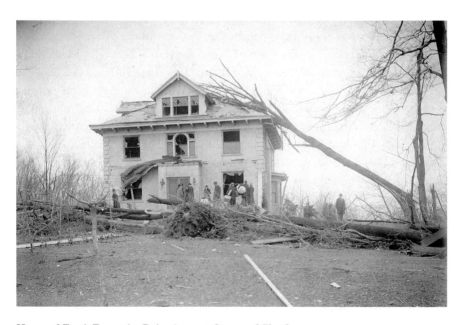

Home of Frank Zumstein, Delta Avenue. *Courtesy of Tom Compton.*

organized relief activities from their headquarters at Hyde Park Town Hall. Notable homes damaged or destroyed included the old Monroe homestead, standing high on a hill of Ault Park overlooking the Ohio and Little Miami Rivers; the home of Frank Zumstein on Delta Avenue, described as "one of the most luxurious homes of the eastern suburb"; and the Kessing home, which was formerly the home of Policy Bill Smith at 2880 Linwood Avenue.

JOSEPH FORAKER

Hyde Park Resident, Ohio Governor, United States Senator

Joseph Benson Foraker (1846–1917) was one of Cincinnati's most prominent citizens. He was twice elected governor of Ohio and served two full terms in the United States Senate.

Foraker was born in Highland County, Ohio, in 1846 and he enlisted, in 1862, at age sixteen in the Union army as a private. He joined the 89th Regiment of the Ohio Volunteers, participated in a number of battles and joined in Sherman's March to the Sea. After the war he graduated from Cornell University, and he began the practice of law in Cincinnati in 1869. In 1879, he was elected a superior court judge; in 1883, he ran on the Republican ticket for Ohio governor but was defeated by the incumbent. Foraker ran again for governor in 1885, and this time he was successful, as he was on re-election in 1887. He was nominated for a third term in 1889 but suffered defeat.

Foraker became a United States senator in 1897 in the days before direct popular elections of senators. The *Cincinnati Times-Star* remarked that "Mr. Foraker's Republicanism was of a militant nature and he frequently figured in incidents which attracted nationwide attention." He was a leader in the run-up to the Spanish-American War of 1898, urging military action to protect native Cubans and American citizens on Cuban soil from what he believed were misdeeds by the Spanish. He introduced a resolution in 1898 demanding independence for Cuba and war with Spain to accomplish this end. His work was instrumental in establishing Puerto Rico as a possession of the United States.

Foraker left the Senate in March of 1909, after two full terms, upon the inauguration of fellow Cincinnatian William Howard Taft as president. Foraker returned to the practice of law in his adopted hometown. He died eight years later of "hardening of the arteries" at his Hyde Park home at the corner of Madison and Grandin Roads, where Springer School stands today.

CHAPTER 5

DEVELOPING THE GREAT HYDE PARK ESTATES

1930–1969

The years 1930 to 1969 saw the completion of the second wave of home building that was started in the 1920s. As automobile transit became more popular, the main arteries from downtown to Hyde Park—Columbia Parkway and Torrence Parkway—were built in 1938, even as the Torrence Station of the Pennsylvania Railroad closed in 1933. The last streetcar ran in 1950, and the car barn in East Hyde Park was demolished to make room for retail and restaurants. Also, most of Hyde Park's grand estates were bulldozed during this thirty-nine-year stretch; The Pines, Elmhurst, Belcamp, Rookwood and the Hermitage all met their end, replaced by Walter Peoples Middle School, the Regency Condominiums and more land for housing. The Hyde Park Town Hall was demolished in 1960 to make room for a gas station. And the Hyde Park Plaza opened in 1962, after an epic seven-year battle over its zoning.

HIGHLIGHTS

1930s

Ohio governor Myers Y. Cooper and Speaker of the House Nicholas Longworth, both Hyde Park residents, spoke at the July 4, 1930 dedication of the Ault Park Pavilion. The park still was not finished by this date, but the pavilion was. The tradition of an Independence Day band concert, followed by fireworks, began that day.

Ladies outside the Methodist Church on Grace Avenue waiting to use an outhouse erected after the water works closed in the aftermath of the 1937 flood. *Courtesy of Rudy Heath.*

While Cooper's Myers Y. Cooper Company was principally a builder of homes at the time, it branched out in 1931 when it built the Cooper Building at 2645 Erie, on the southwest corner at Edwards, which is a five-story, mixed-use retail, restaurant, office and apartment space.

March 31, 1933, was the last day for the Torrence Station of the Pennsylvania Railroad upon the opening of Union Terminal in Queensgate. Theodore Roosevelt had alighted a train from this station years earlier en route to visit his daughter, Alice, who was married to Nicholas Longworth and who resided at Rookwood.

Cincinnati Bell constructed its red brick building at the corner of Delta and Griest Avenues in December 1936, bringing dial telephone service to Hyde Park. This building is still in use today by the telephone company.

The city engineer's office sought to enlarge and extend what was then Columbia Avenue, a two-lane road that connected Hyde Park via Torrence Road to downtown. By 1938, plans were drawn up for a new Columbia Parkway, which was wider than Columbia Avenue, and a new Torrence Parkway to run about 350 feet west of the then existing two-lane Torrence Road. These plans became a reality with federal government grants. The city needed to buy properties along the south side of Columbia Avenue (including the historic George Torrence log cabin) and also properties on the west side of Torrence Road for the to-be-constructed Torrence Parkway.

Students on break on the front steps of Withrow High School, 1938. *Courtesy of Jack Cover.*

The former sanctuary for Holy Angels Catholic Church, which it sold in the early 1920s, was one of these buildings that was demolished for the building of the new Torrence Parkway. The hillside north of Columbia Parkway was cut and then used to fill the south side of the road. The five-lane Columbia Parkway and four-lane Torrence Parkway opened in 1938.

That year, another land-use dispute arose in Hyde Park. One hundred and two of the original Hyde Park Syndicate lots just west of Hyde Park Square had restrictive covenants limiting the property to residential use only. This became an issue in 1938 when plans were made to double the size of Hyde Park Square with a second square one block to the west of Edwards on Erie, ending at Zumstein Avenue. The second block of the expanded square was

to have retail on the ground floor and apartments above, with a park in the middle of Erie Avenue. The city changed the zoning to allow commercial use. Most residents affected by the covenants agreed to the change, but four families challenged the rezoning as being inconsistent with the restrictive covenants. Plans to extend the square were put to an end when the covenants were enforced in court. (See Chapter 10, Hyde Park Square.)

1940s

In 1941, Summit Country Day School, then an all-girls school, started the Summit Boys School for grades one through eight. World War II came later that year and it put on hold many plans for change, especially to Hyde Park. While it is doubtful that Hyde Park was on any bombing priority list of the Germans or the Japanese during the war, Hyde Park was prepared. The May 31, 1942 *Cincinnati Enquirer* reported that "[i]f Cincinnati were to be bombed tonight, one of the safest places in the city would be the big block

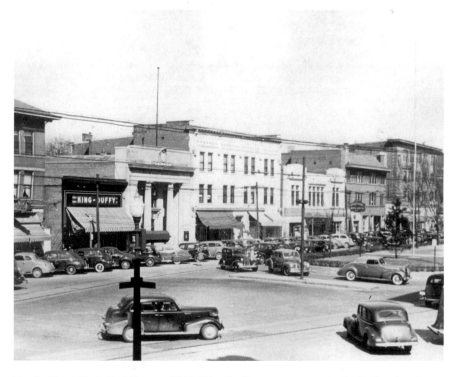

North side of Hyde Park Square, 1940. King Duffy was a grocery that had taken the place of a Piggly Wiggly grocery. *Courtesy of Mike Judy.*

in Hyde Park bounded by Observatory Road, Madison Road, Erie Avenue and Berry Avenue. This is Sector 4 of District 5 and—thanks to the work of A.M. Lewin, Jr., one of its senior air raid wardens—civilian defense officials in that sector probably have more complete information about their sector than is the case in any other area in the city."

Debates about what to do with the Grandin Road Viaduct raged during 1943. (See Chapter 6, Hyde Park Changes.)The bridge was built quickly in 1905, connecting Grandin Road in Hyde Park to Grandin Road in Mount Lookout. It was also built without modern engineering protections. The bridge had been a frequent location for suicides, and faulty construction often closed it for repairs. The city made the decision in November 1943 to spend $95,000, the amount estimated to make the bridge usable for another thirty years.

The southeast corner of Grandin Road and old Torrence Road, where the Grandin House apartments sit today, was the site of a saloon and restaurant in 1904. By the 1920s, the lot became an automobile sales and service station. In October 1943, Johnny Dell Motors, Inc., leased the property. In announcing the lease, Dell stated his belief that "[i]n the postwar era, the motor car business will reach tremendous proportions, and...dealers who now plan both sales and service to shape into the new period will be in a position to enlarge and enrich their opportunities."

1950s

The Kilgour family had a controlling interest in the Cincinnati Street Railway Company, which brought the trolleys and the tracks to Hyde Park from the neighborhood's very beginnings in the 1890s. But trolley transportation was being replaced by bus transportation in the 1950s. On October 3, 1950, the Hyde Park Car Barn on Erie Avenue near Marburg Avenue closed. That same year, Knox Presbyterian Church on Observatory Avenue finished an expansion of its Observatory Avenue building, adding its chapel and school facility.

The 1950s saw the demolition of the Rookwood and Belcamp mansions, described later, but it also saw the building of several churches still present in the neighborhood today. In 1951, the Kilgour heirs sold eight acres to the Dominican Order of the Catholic Church at 3020 Erie Avenue—land that they had neither sold to Myers Y. Cooper nor kept as part of The Pines estate. This property extended all the way back to the east side of Raymar and included the land that today is Cloister Court. The Dominicans'

cloistered order of nuns had been in East Walnut Hills, where the current Saint Margaret Nursing Home sits, and, in 1953, the nuns moved to their new building, the Monastery of the Holy Name. The Episcopal Church of the Redeemer moved that same year from its original church building at 3443 Edwards Avenue, between Erie and Observatory, to its present building, at the corner of Paxton and Erie Avenues. This sanctuary was consecrated on November 15, 1953.

In April 1958, the Vista Gardens $3 million co-op project began to be developed by Vista Avenue, on the site of a portion of the original Isaac Ferris purchase of 1798. Also in 1958, plans were set into motion for the development of Corbin Acres, which was a tract on the south side of Grandin Road, across from the Cincinnati Country Club. The original plans called for the construction of Corbin Avenue and ten, one-acre homesites, some of which overlook the Ohio River.

The City of Cincinnati bought in 1959 the Hyde Park EUB church building at 2753 Erie Avenue for $80,000 to raze for parking for Hyde Park Square. This project soon thereafter failed when merchants on the square declined the assessments necessary to finance this purchase. The city later sold the church building for office space, which is its use today.

1960s

One of the saddest changes that came to Hyde Park occurred in 1960 when the Hyde Park Masons demolished the 1901 Hyde Park Town Hall, at the northeast corner of Erie and Michigan, to lease the land for the next forty years for use as an automobile filling and service station. The Masons had been studying sale of the building for at least twenty-five years, but this important piece of Hyde Park history met an unfortunate end to begin the decade of the 1960s. The Albers grocery store at 2675 Madison Road was sold by Albers in 1961 to Busken Bakery in anticipation of Albers's move to the new Hyde Park Plaza. Busken keeps its offices and largest bakery at this Madison Road site to this day. Hyde Park Plaza did finally open on November 29, 1962—the culmination of a seven-year legal battle, described in the next section. Mills Judy completely renovated the Mills Judy Building at the northeast corner of Erie and Edwards in the summer of 1963, giving the building the exterior appearance still present in 2010.

The year 1964 saw the girls leave the Saint Mary High School and move to the brand-new Marian High School, near the corner of Grandin and Madison, in the building where Springer School meets today. Saint Mary

elementary students moved to the high school building, which they still use today, and the 1903 building they had used was razed for parking. The very next year, 1965, Holy Angels Elementary School closed and it was combined with the Saint Francis de Sales school in East Walnut Hills. The Hyde Park Community United Methodist Church expanded its building across the entire front of Observatory Avenue, consecrating its chapel and education wing on May 15, 1966.

THE HYDE PARK PLAZA CONTROVERSY

Of all the many Hyde Park land battles, the dispute over development of the Hyde Park Plaza may have been the longest lasting. It may also have had one of the most significant long-term impacts on the neighborhood. There is some question whether the property is in Hyde Park or Oakley—the Oakley branch of the post office sits today in the Hyde Park Plaza—but it is an important part of the story of Hyde Park.

Plans were announced on August 16, 1955, for the development of a twenty-nine-acre property fronting one thousand feet on Paxton Avenue and seventeen hundred feet on Wasson Road. At the time, the land was an undeveloped field. Disputes have erupted time and again over the last 135 years over changes to the neighborhood that involve anything other than construction of single-family residences; the "mother of all battles" occurred over the plans for the Hyde Park Plaza.

The planned retail development of the plaza required a zoning change, and this gave opponents the opportunity to voice their opinions. While some said that the shopping center would be a "death trap" for children because of increased traffic, it seems the real opposition came from shopkeepers. The estimate was that "the plaza would be a 'ruthless element' affecting nine out of ten businesses in other nearby shopping areas. There aren't enough customers to go around."

Cincinnati City Council refused to change the zoning, so the plaza's proponents went to court in 1957. In August 1958, the Court of Common Pleas ruled the zoning ordinance unconstitutional, and it called the city's action in refusing the zoning change to be "unreasonable, arbitrary and confiscatory." The Hamilton County Court of Appeals upheld the lower court decision in 1959 and the Ohio Supreme Court refused to consider the issue further. In July of 1960, city council passed a new zoning ordinance approving plans for the shopping center.

The Hyde Park Plaza opened for business November 29, 1962. Its initial tenants included Albers, Bowdean Food Shoppe, Burkhardt's, Carousel Corner, Central Trust, Eastern Plaza Cleaners, Hyde Park Plaza Barber Shop, Hyde Park Plaza Jewelers, Kroger, Martin's Town and Country Fashions, Model Shoe Store, Plaza Photo–Hi-Fi, Ricardo Beauty Salon, Security Savings and Loan, Sherwin-Williams Paints, Shoe Repair, Shuller Shoes, Square Appliance and Furniture, State Liquors, Walgreens and Woolworth's.

THE END OF HYDE PARK MANSIONS

This era saw the end of the grand Hyde Park estate homes. They had been erected years earlier by families with great fortunes at their disposal and at a time when Hyde Park real estate was valuable for farmland. The grand estates had outlived that era and were expensive to maintain. Their land now either had greater value to the heirs for real estate development or the property (in two of these instances) was needed for public purposes.

Elmhurst was the estate home of William Groesbeck (1815–1897), on and about what is now Elmhurst Avenue. (See Chapter 2, Farmland Becomes Mornington.) Groesbeck was an attorney, and he gained fame representing President Andrew Johnson in the Senate impeachment proceedings in 1868. His three-story, thirty-eight-room house sat on thirty-five acres overlooking the Ohio River. A number of lots had been sold off over the years, but his heirs razed the mansion and sold off what was left of the property in 1941. The houses built on this land are expensive houses in their own right, many of which sell today for a million dollars or more.

Rookwood was built by Joseph Longworth in 1848 on more than one hundred acres on the north side of Grandin Road, where the Rookwood subdivision is today. Longworth's grandson, Nicholas Longworth, speaker of the House of Representatives, passed away in 1931 and the house was little used by the Longworths thereafter. It gradually fell into disrepair, and the heirs gradually sold off pieces of the property. The last fourteen acres of the Rookwood property, including the rundown house, were sold to home builder Myers Y. Cooper in June of 1950. Cooper tore down Rookwood and built twenty-five homes on the property. As with the properties on the former Elmhurst estate, properties in the Rookwood subdivision also sell today for significant sums.

Developing the Great Hyde Park Estates

Belcamp, 150 acres, was Nicholas Walsh's estate, located north of Grandin and bordered by Linwood and Edwards. (See Chapter 3, The Mornington Syndicate Begets Hyde Park.) Walsh, a distiller, had passed away in 1915; his widow, Susanna, then married Frederick Hinkle, and she lived in the house until she passed away in 1952. At the time of its sale in 1954 to developers, this large tract was said to be the largest undeveloped section of privately owned land in the United States that was located so close to a large, metropolitan area. But its sale meant change for the neighbors as reported by the May 8, 1954 *Cincinnati Post*:

> *The old home and its 150 acres of beautiful grounds have been sold to a realty company which plans to wreck the house, subdivide the land and build homes that will sell from $20,000 to $35,000 each.*
>
> *To folks living near the old estate, the sale means the loss of a cherished bit of country atmosphere which children of the neighborhood especially have enjoyed for years.*
>
> *John Buckner, the gardener, still living in a cottage on the grounds, knows the story of how the children of the surrounding suburban areas have always used the old place as a playground and exploration site.*
>
> *"I was hired back in 1914," said Mr. Buckner. "There was plenty of work on the place then. We kept six cows and two horses and plenty of poultry. We used the horses to cultivate a large garden area and to do the mowing about the place.*
>
> *"It was only natural for children to want to come in and look around. We never objected so long as they behaved themselves.*
>
> *"Mr. Hinkle always was pretty nice about it. Before he died in 1950, children would come from all over town and ask permission to camp on the grounds for the day, or maybe overnight.*
>
> *"At one time Mrs. Hinkle had an arrangement with the Girl Scouts. She allowed them to use the grounds as a day camp about four days a week during the summer. Mrs. Hinkle was one of the finest women I ever knew. I never heard her say a cross word."*

The Pines was taken by the Cincinnati Board of Education through eminent domain in 1965 to build Walter Peoples Middle School because Withrow High School was running out of room. The school board took the house after a bitter fight with neighbors the year after Martha Cooper, the wife of Myers Y. Cooper, passed away. (See Chapter 9, The Pines.)

The Hermitage was encroached upon by the development of Interstate 71 and the Dana Avenue interchange. In 1965, the year after Lucien Wulsin Jr. died, having spent his whole life residing in the house, his heirs sold the remaining acreage for the development of the Regency Condominiums, at the corner of Madison Road and Dana Avenue. (See Chapter 3, the Mornington Syndicate Begets Hyde Park.) This important chapter of the history of Hyde Park had come to an end.

CHAPTER 6
HYDE PARK CHANGES
1970–2009

The four decades from 1970 to 2009 saw the gradual evolution of Hyde Park Square from neighborhood shopping center to a more regional specialty shopping destination. This era also saw gradual changes throughout Hyde Park. Very few of these changes were themselves significant, but in the aggregate the change can be viewed as substantial.

Land-use disputes have been an important part of Hyde Park since its very beginnings, and these forty years proved no exception. Virtually any use of property that changes a prior use or that is other than a single-family residence will bring a dispute and sometimes a court battle. The character of these issues did not seem to be different than in past decades, but their frequency seemed to increase.

HIGHLIGHTS

1970s

The Carnegie Library had opened in 1912, a gift from the city of the property and of Andrew Carnegie for the building and books. Originally, it was stocked with six thousand volumes. In 1970, the fifty-eight-year-old building was substantially changed and updated. The facade was changed from that of a traditional Carnegie library but was in keeping with the architecture of the neighborhood. A large addition was put on the back of

the building, and the basement auditorium was removed to make room for additional books. The library's collection had grown from six thousand to more than fifty thousand books, records and magazines.

Also in 1970, the new Summit Primary School building, on Convent Lane, was opened, with students moving from the main 1890-era building to this new facility. The next year, the flatiron building across the street from the Grandin House at the corner of Torrence, Grandin and Madison Roads was torn down and replaced with a small park, named for Thomas H. Clark, the Cincinnati lawyer who donated the site to the city for a park.

After many years of discussion and repairs, the Grandin Bridge needed either additional renovation or removal. Cincinnati City Council voted November 6, 1974, to demolish the bridge, and it was razed in the summer of 1975. Lower Grandin Road in Hyde Park and upper Grandin Road in Mount Lookout have remained separated ever since.

In 1976, the nine-story Grandin House apartment building opened at 2101 Grandin Road, at the corner of Madison Road and Torrence Parkway, after the site had been a car dealership for the previous fifty years. This building was part of a wave of new apartment buildings being built on the periphery of Hyde Park.

1980s

Chelsea Moore Co., a developer, sought a zoning change from the city planning commission in the summer of 1980 to put a twenty-eight-unit condominium complex on 12.5 wooded acres on Grandin Ridge Road, which connects lower Grandin and Alpine Terrace. The plan called for condominiums from 1,800 to 2,200 square feet, which were to sell for $175,000 to $250,000. More than one hundred area residents protested the plan for this multifamily development. The city planning commission denied the change on multiple grounds: the units would be higher than neighboring houses; the units were not compatible with the setting; the traffic that would be generated was undue; and the sloping terrain on which the units were to be built might cause landslides that would affect neighbors.

In June of 1981, the last class graduated from Marian High School, and the girls were consolidated into the Purcell-Marian High School in East Walnut Hills. The church sold Marian and Holy Angels Elementary School, which had been closed since 1965, to Springer School, which has occupied the former Marian High School building since 1982. Holy Angels Elementary school was razed to make room for Springer's playground.

Hyde Park Changes

The First Church of Christ, Scientist, bought a house at 3035 Erie Avenue in 1982. The church, which had been in Hyde Park for many years, sought to take down the house and build a simple one-story, red brick church across from Walter Peoples Middle School. Also, the church planned a parking lot at the rear of the property. Area residents fought this change away from single-family use, but they were rebuffed. The Christian Scientist church opened there in 1983.

Hyde Park Square at one point in the early 1900s was home to three different "moving picture" houses. That era came to an end when the Hyde Park Theater at 2718 Erie Avenue showed its last movie on October 25, 1983. The Hyde Park Theater had been showing second-run movies for a number of years, but demand was insufficient to keep the theater operating.

Late winter of 1988 saw another dispute, this one over the replacement of a closed Sohio service station at the southwest corner of Observatory Avenue and Edwards Road. A gas station had been at this corner for many

R.K. LeBlond Machine Tool Company plant at the intersection of Madison and Edwards Roads in 1964. The plant was demolished in 1989, and the Rookwood Pavilion Shopping Center was built on this site in 1993. *Courtesy of Mike Judy.*

years, and UDF sought to open a twenty-four-hour convenience store and gas station there. More than three hundred people showed up at meetings of the Hyde Park Neighborhood Council in February and March of 1988 opposing this move. "This is a residential neighborhood, period," said Jerry Hahn of nearby Hampshire Avenue. In response to the neighborhood reaction, UDF dropped its plans on March 18, 1988. Instead, the corner was redeveloped in 1989, where clothing retailers and a dry cleaner occupy the first floor of the building with office space on the second floor.

The Dominican Order's cloistered nunnery at 3020 Erie Avenue started in 1953, and it closed in 1989 due to a lack of new members. That same year saw the closing of the Norwood plant of the R.K. LeBlond Machine Tool Company on a substantial tract that abuts Hyde Park at the southwest corner of Madison and Edwards Roads. This latter closing especially would work a dramatic change to Hyde Park in the decade to come.

1990s

Thirty years after the Hyde Park Plaza opened, its owners declared bankruptcy in 1992. The property was bought out of bankruptcy and renovated, and a number of new tenants were enlisted to occupy the space. The plaza came back on line in 1994 after a $5 million renovation, just in time to meet the competitive challenge of the Rookwood Pavilion shopping center. The pavilion opened in 1993, occupying the space of the former LeBlond machine tool factory, just across the city line into Norwood on Madison Road. Rookwood represented the first major, new retailing presence in the area since Hyde Park Plaza opened in 1962.

A lingering question was how Hyde Park Square merchants would be affected as a result of all this new retail space within a mile of the square. That question was answered in part in June of 1994, when Drew's Bookshop on Edwards Road, which leased twenty-three hundred square feet of space, found that it could not compete against Joseph-Beth Booksellers in Rookwood, which leased twenty-three thousand square feet of space. In April of 1995, the long-awaited parking lot immediately behind the northern facade of the square's retail opened—after almost forty years of planning, fits and starts—helping the square's merchants. The continuing effect on the square of the additional Rookwood competition has been uneven, but it certainly has caused the development of additional specialty types of retailers instead of retailers aiming for a more mass audience, who generally lease space in Rookwood or Hyde Park Plaza, instead of on the square. This

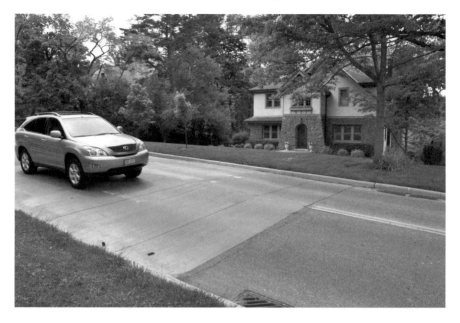

This is one of the controversial speed humps slowing traffic on Edwards Road. *Courtesy of the author.*

trend continued when Rookwood Commons opened in 2000, more than doubling the size of the Rookwood shopping area.

Today, speed humps have sprouted throughout many streets in Hyde Park as part of attempts at "street calming." But this was not always the case. The battle started in 1994 when several residents on Edwards Road south of Observatory Avenue called upon the city to place seven speed humps, five hundred feet apart, in order to slow traffic. While the speed limit on that stretch of Edwards is thirty miles per hour, a number of drivers were clocked going in excess of sixty miles per hour. The original humps were three inches tall but were later reduced to two and one-half inches after an initial demonstration period.

While Edwards Road neighbors were pleased with the humps and the reduced speed of local traffic, some Rookwood neighbors, Grandin Road neighbors and drivers cutting through the neighborhood to Torrence Parkway were outraged, claiming that emergency vehicles would be slowed as a result of the humps and that this public road was engineered more like a private drive in order to please the well-to-do residents. Despite the protests, late in 1996 the decision was made to keep the speed humps since the method was effective. The use of speed humps has been replicated on

additional Hyde Park streets after this experiment, especially on streets that can be used a "cut through" to avoid roads that are more heavily traveled.

In 1995, another street controversy erupted with some Observatory Avenue residents who grew outraged that the city was considering striping the road along its entire length for four-lane traffic (it mostly is used as a very wide two-lane road, except at intersections). The neighbors responded by parking their cars along the length of Observatory, forcing traffic into two lanes. The city's plans to restripe withered on the vine.

The year 1999 saw several closings and changes. Walter Peoples Middle School, which opened in 1967 on the former site of The Pines, saw its last class in June of 1999. Clark Montessori School later moved into the building from its East End location. The 140-year-old Piatt-Grandin house, at the corner of Convent Lane and Grandin Road, was torn down by the Summit Country Day School, which had bought the house in 1996. City engineers estimated it would take at least $500,000 in repairs to make the house livable. Permission was given by the city to tear it down, and it was razed by the Summit in July of 1999. Almost directly across Grandin Road to the north of the Piatt-Grandin house was the Holy Angels Catholic Church. December 1999 saw its last service there after almost 140 years, and the parish merged into Saint Francis de Sales.

2000s

Hyde Park Square saw two important changes during this decade. The Hyde Park Masons had demolished the old Hyde Park Town Hall in 1960 to lease the land at the northeast corner of Michigan and Erie for a Shell service station. In 2003, the gas station came to an end, leaving Hyde Park with the UDF on Erie and Marburg as its only gas station. In place of the Shell station, a six-story condominium building, Michigan Terrace, was built in 2005, a large presence at the corner of the square. The city performed a major renovation of Hyde Park Square in 2003, changing a number of trees along the square and making other cosmetic changes. (See Chapter 10, Hyde Park Square.) The changes were embraced by the square's retail community, but they were disapproved of by a number of longtime neighborhood residents as being inconsistent with this turn-of-the-twentieth-century development.

Several changes and additions to neighborhood churches occurred during this decade. On October 31, 2001, the Hyde Park Community United Methodist Church bought the Monastery of the Holy Name from the Dominican Order. The church's plans for this building in 2005 caused an eruption with

its neighbors, which is unresolved as of this writing and described more fully later. That same year the Methodist church dedicated its new stair tower at its building at 1345 Grace Avenue. Knox Presbyterian Church on Observatory Avenue tore down two apartment buildings it owned on Observatory, adjacent to its sanctuary, and it built a substantial $6 million addition facing Observatory that was completed in 2006 with a big multipurpose room and additional meeting spaces. And the Hyde Park Methodist church opened its new welcome center at its Grace Campus in 2007.

Summit Country Day School embarked on an ambitious renovation and building campaign in the early 2000s, razing and completely redoing its primary and Montessori school buildings, adding new athletic fields and space for parking and renovating its main, 1890-era building. Tragedy was fortunately averted the morning of January 18, 2004, when a portion of the main building collapsed due to excavation work that had weakened a part of the foundation. Given that it was a Sunday morning, no one was present in the building. Temporary homes for the programs occupying that space were found elsewhere and construction proceeded apace. The new primary school was then able to open in the fall of 2004.

A neighborhood elementary school had been found at the northwest corner of Observatory Avenue and Edwards Road since 1823, but this came to an end in 2005 with the closing of the Hyde Park Elementary School. Neighborhood parents had largely stopped sending their children to the school for some time, and the board of education did not believe that the school fit in with its plans for the future. Since the spring of 2005, the school building has hosted other schools while their buildings are being renovated, but there is no plan as of this writing to re-start the Hyde Park school with its own student body. The Kilgour Elementary School was one of the schools using Hyde Park while its building was renovated from 2005 to 2008, and Kilgour re-opened then on Herschel Avenue after a substantial renovation and addition to its facility.

DISPUTE OVER THE HOME FOR MENTALLY CHALLENGED ADULTS

The 3400 block of Stettinius Avenue, between Erie and Observatory, is a part of the original property developed by the Hyde Park Syndicate, dating to the early 1900s. The entire block was either single-family or two-family residential homes until the fall of 1978. That year, the Resident Home for the Mentally

Retarded of Hamilton County purchased the single family house at 3437 Stettinius for use as a group home for up to six mentally disabled adults who would live with counselors at the site. The 1905 home needed and got a fire escape and sprinkler system installed, given its new use for multiple people.

Neighborhood residents fought the change. Twenty-one of them filed suit in the Hamilton County Court of Common Pleas, claiming that the "Cincinnati zoning ordinance and the Ohio law which permit group homes in residential neighborhoods are unconstitutional because they allow spot zoning and violate the equal protection rights of residents."

Longtime trial court judge Thomas Crush heard the dispute. The *Cincinnati Enquirer* reported that:

> *Attorney Robert Manley, representing the neighbors, completed his case late Monday.*
>
> *According to Manley, in his opening statements, "There is no more gentle group of people on this Earth than mentally retarded people." That is not the issue in this case, he said. The Resident Home for the Mentally Retarded "stole into this neighborhood like thieves in the night," he said. Like the clients he represents, Manley maintained that the use of the property at 3437 Stettinius Ave. is "inconsistent" with surrounding property.*
>
> *The city's recently enacted ordinance, which allows such facilities in Cincinnati's neighborhoods, is being questioned by Manley and his clients.*

Judge Crush concluded in March of 1981 that the group home was consistent with the city's zoning ordinance and that it did not violate the neighbors' constitutional rights. He permitted the group home to go forward, and almost thirty years later, the home remains.

HONOR YOUR PROMISE?

The Hyde Park Methodist Church Expansion Controversies

The Hyde Park Community United Methodist Church built its first sanctuary in 1880, on the corner of Grace and Observatory, on land donated by the Kilgours. It consecrated the Gothic sanctuary in 1927, which is still present today, and substantially added onto the building in 1966 with its education wing and chapel. The growing church, with a membership of thirty-one hundred, found itself out of room by 1997 and embarked on a plan to

purchase the nineteen homes on the block behind the church, bordered by Grace, Meier and Griest Avenues, over a twenty-year period. The ultimate plan was to add building space and a parking garage. Since 1927, the church made a deliberate effort to be a community church—open to all comers, including groups such as the Job Search Focus Group that aids people looking for new employment, the Boy Scouts and the like. This block behind the church contains a number of rental properties and homes for first-time home buyers, but it also includes several longtime residents.

Some neighbors supported this plan, but a number of them objected and protested with yard signs. After the church purchased six homes, it announced it would buy no more. The *Cincinnati Enquirer* on September 26, 1997, reported that:

> *But the promise to quit buying homes hardly relieves some neighbors.*
>
> *"This is not a victory for us. Maintaining control or ownership of five or six properties means they haven't abandoned their expansion plans; they've only postponed them," said James A. Coppens Jr., who is leading the crusade against expansion.*
>
> *"There aren't any clear winners. If the church can't build its programs and meet the needs of the people, that to us is a loss. But if they tear down our homes, that's a huge loss."*

In the summer of 1998, the church announced that it was changing its plans, and that with the exception of two homes immediately behind the church on Grace Avenue, it would not be tearing down other homes on the block behind the church building for parking. Instead, the church focused on a long-range plan of converting the existing gym to two floors of classrooms, adding a gym on top of the Meier Avenue parking lot, putting a two-floor parking garage over the existing parking lot and then building additional space above the parking garage.

The church came up with a different plan and thought it had solved its space problems in the fall of 2001 when it bought the defunct Monastery of the Holy Name at 3020 Erie Avenue from the Dominicans. But this would not be the case. The church moved its Meals on Wheels kitchen to the Erie building from its Grace building, with financial assistance from the city and a generous donation by Carl Lindner. It also used the Erie building for its Interfaith Hospitality Network (IHN) sleepovers. Nationwide, IHN churches host homeless families overnight for a one-week stay when they move to another church. The families meet in classrooms during the day at a central IHN site in Price Hill, while the school-age children attend classes. More

than twenty Cincinnati area churches host IHN, including the Episcopal Church of the Redeemer, just five doors down Erie Avenue from the Methodist church's Erie building. Also, the church at Erie hosted weekend retreats for the ecumenical Walk to Emmaus six times per year.

In 2004, the church announced an ambitious building campaign to update the Erie facility, build a multipurpose room at Erie, knock down two houses on the block bounded by Meier, Observatory and Paxton Avenues for parking and do interior renovations of the Grace building. The church's neighbors erupted, placing "Honor Your Promise" signs at many neighboring houses and hosting a meeting at Clark Montessori School in a protest that drew more than three hundred people. The "promise" related to the earlier statement that the church would not put additional parking on the block behind the church on Observatory (with the exception of two houses), even though the church's plan was to put parking on a different block.

In response to financial constraints, the church greatly scaled back its plans and sought only to do interior renovations at its Erie and Grace buildings. The neighbors did not oppose the Grace renovations, and these were accomplished. But they did oppose the Erie renovations, which consisted of adding central air conditioning, updating restrooms and building an interior wall. Neighbors based their objections on the programming at Erie of hosting the homeless through IHN, feeding shut-ins through Meals on Wheels and hosting the ecumenical weekend retreats. They did not oppose this programming, but they believed that such activities should take place somewhere other than in Hyde Park. A zoning battle then ensued about whether the church needed zoning clearance for its interior renovations—an unfortunate battle that continues as of this writing.[22]

GRANDIN BRIDGE

1905–1975

The Grandin Bridge, also known as the Grandin Road Viaduct or Delta Avenue Viaduct, was torn down in 1975. Many Hyde Park residents are unaware that the bridge ever existed, which connected lower Grandin Road in Hyde Park with upper Grandin Road in Mount Lookout, almost directly atop the Grandin Bridge apartments off of Delta Avenue in Mount Lookout.

The bridge was completed in 1905 in just ten months at a cost of $202,000. It was 1,100 feet long and crossed 150 feet above Delta Avenue.

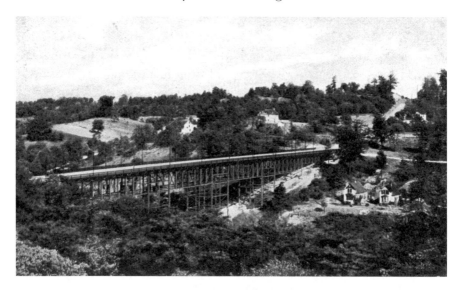

The Grandin Bridge, also known as the Grandin Viaduct or the Delta Viaduct. It connected Grandin Road in Hyde Park (left) with Grandin Road in Mount Lookout (right). *Courtesy of the Public Library of Cincinnati and Hamilton County.*

Construction of such a bridge today would be a mean feat of engineering, and the engineering and construction of the Grandin Bridge was an issue throughout its lifetime. The first call for its demolition came in 1943 when it was closed for a period because city engineers were concerned that a strong wind could cause it to collapse. A November 3, 1943 article from the *Cincinnati Post* describes the reaction of some residents:

> *There was tragedy in the 38-year life of the Grandin road viaduct over Delta Avenue, ordered closed by City Manager Sherrill for reasons of safety.*
>
> *But the suicide leaps, auto and construction deaths weren't foremost in the minds of persons living in the shadow of the span as they expressed mild elation Wednesday over its probable passing.*
>
> *Instead there came memories of eggs splattering on pedestrians' heads, Halloween dummies suspended from cross girders and family washings ruined by dust from the structure.*
>
> *"It was a regular nuisance," said Mrs. Rose Honey, 575 Delta Avenue.*
>
> *"Look at the holes in my slate roof!" exclaimed a neighbor. "Kids made 'em by tossing stones from the top of the bridge."*
>
> *"But the viaduct surely could tell some tales if it could talk," added George Noerr, 588 Delta Avenue. He referred to use of spaces under the structure for impromptu "lover's lanes."*

Instead of demolition, city council voted in November of 1943 to spend almost $95,000, which was promised to extend the life of the bridge for thirty to forty years; the bridge reopened the following year. In 1958, a clamor began anew for raze the bridge sparked by the hazard of objects being thrown from the viaduct onto the cars on Delta Avenue below.

The *Times-Star* editorialized against its destruction:

> *The clamor for the viaduct razing follows the old familiar pattern. Something is in the way, is a possible hazard or requires attention. So tear it down! Get rid of it! Pay no heed to the fact that it is part of Cincinnati, a contributor to its unique characteristics and can be made to serve a purpose. Away with the old, on with the new! It's a pattern that leads to bankruptcy of the finer things in a community.*

But the bridge was not torn down then.

Discovery of a break in a steel member in March 1962 caused the immediate closing of the viaduct. The city again wanted to tear it down, but Hyde Park and Mount Lookout neighbors rebelled. City council appropriated $110,000 to repair the bridge, and it reopened on June 13, 1963.

The bridge remained open for another eleven years when it became apparent that the bridge required significant structural repairs or replacement—at a minimum cost of $1.1 million. After much community debate, city council voted in November of 1974 to demolish the bridge. The bridge was closed to traffic effective January 1, 1975, and torn down later that year.

JOHN AND CHARLES KILGOUR

The Money and the Vision Behind Hyde Park

John (1834–1914) and Charles Kilgour (1833–1906) transformed hundreds of acres of farmland just five miles from downtown Cincinnati into Hyde Park and Mount Lookout, which have become some of the most valuable real estate in the city. The Kilgours bought large tracts of farmland there. They then developed the transportation infrastructure to connect these areas to downtown, which made their farmland substantially more valuable to be sold as town lots. Thousands of Hyde Park and Mount Lookout homes were built during their lifetimes.

The Kilgour brothers lived remarkable lives in Cincinnati in an age when they could and did amass great fortunes. They made their initial fortune the old-fashioned way—they inherited it from their father, John Glenny Kilgour (1796–1858). The Kilgour brothers used this money to become forerunners in rapid transit, developing horse-drawn bus lines, and later electric trolley lines, throughout the city. They also expanded their family's railroad holdings. With the advent of the telegraph and the telephone, they organized and led the city's leading telegraph company that they later turned into the Cincinnati Bell Telephone Company.

DAVID KILGOUR

The Kilgour story as it relates to Hyde Park starts in Scotland, where Charles and John's great-uncle, David Kilgour (1767–1830), lived before immigrating

to Cincinnati in 1798. Cincinnati had been founded only ten years earlier, in 1788. When David arrived the city had a population of approximately five hundred people; the population grew to twenty-five thousand by the time David died three decades later. David Kilgour was industrious and he quickly developed a wholesale grocery business, supplying parts west with groceries he shipped using river transportation in this era before the railroads existed. The Allegheny Mountains formed a natural barrier from eastern competition, and he grew his business quickly with his own fleet of river transports. Steamboats came to the Ohio in 1812, and David operated a fleet of four—*George Washington*, *Hibernia*, *Helen McGregor* and *Lady Franklin*—in addition to a fleet of other river boats. He was the largest wholesale dry goods supplier in the West.

In 1812, David married Sarah Kennon Taylor (1770–1821). Sarah, a divorcee, had brought her son, Griffin Taylor,[23] with her to Cincinnati, and David put Griffin to work in one of his dry-goods stores. Also in 1812, David's nephew, John Glenny Kilgour, immigrated to Cincinnati from Bristol, England, and likewise he was put to work for his uncle. The business was named Kilgour, Taylor and Company upon Taylor's admission to the partnership in 1817; it was fabulously successful. John Glenny Kilgour became a partner in 1820. Reuben Springer married David's niece, Jane Kilgour (John's sister), and was named a partner in 1830. Several years later, Reuben's brother Charles married Catherine Kilgour, another of David's nieces (and another of John's sisters), and he too became a partner. When the company was liquidated in 1840, ten years after David's death, it was valued at more than a quarter million dollars.

David also invested wisely in real estate during this era when land values in Cincinnati surged in these first days of rapid population growth. A lot at Front and Main Streets on the downtown riverfront, which sold for $2.00 in 1798, brought $14,250 in 1840. The value of property during this early period in the life of the city was said to double every three years, which made landholding speculation quite lucrative. David recognized this opportunity and bought up a number of downtown lots.

Kilgour built one of the city's first mansions, known as the White House, on a fourteen-acre property near Lytle Square. The house was at the end of Third Street, at the base of the Mount Adams hill. Henry Kilgour, John Glenny Kilgour's father and the brother of David, immigrated to Cincinnati in 1817 from Bristol, England, with his wife, Catherina, and their other children, Henry Jr., Margaret, Mary, Elizabeth, Catherine and Jane. Henry was persuaded to come to Cincinnati since business fortunes in Bristol were

deteriorating. He recognized the opportunities that his brother and son had found and decided to join them. Henry's move prompted David in 1818 to buy the land adjoining the White House and to build another mansion next door, Spring Hill, for brother Henry and his family.

David Kilgour's marriage to Sarah ended in 1821 upon her death, and he was remarried in 1825 to Julianna Williamson, who was from a well-to-do family from Baltimore, Maryland. It was the practice at the time for well-to-do people to seek spouses from similarly well-off families, and David was no doubt inspired to marry Julianna for such reasons. David and Julianna had no children together.

In addition to David's wholesale grocery business, he was elected twice to city council and served as a director of a number of the city's first insurance companies and banks. He died suddenly and unexpectedly in 1830; he was sixty-three years old.

David Kilgour's life was the stuff of Horatio Alger-type legend, except for the notable and lamentable fact that he bought and sold at least two male slaves. He arrived in the frontier town of Cincinnati when he was thirty-two and of only modest means. The city grew exponentially for the next thirty-one years, and he took full advantage of the opportunities he had; he helped Cincinnati grow into one of the country's largest cities at the time of his death.

JOHN GLENNY KILGOUR

John Glenny Kilgour took the money he made from Uncle David's wholesale grocery business and invested in new local railroads and in a local bank, greatly multiplying his fortune. It was during John Glenny's time that railroads became commercially viable, and they changed the way American commerce worked. No longer was business dependent upon river and canal transportation; railroads changed American life almost overnight, especially in the North. His bank involvement was critical to the city, too, for in those days following the demise of the Second United States Bank at the hands of President Andrew Jackson, Kilgour helped to supply local businessmen with a ready source of capital that was necessary for the city's continued economic growth.

Like his uncle, David, John Glenny sought a wife of means, and, in 1832, he married Elizabeth Coles Higbee of Trenton, New Jersey, whose family was wealthy with substantial land holdings in and around Trenton. John Glenny brought Elizabeth Kilgour home to the White House mansion in

lower Mount Adams, which he had purchased that same year from his uncle's estate.

In 1843, John Glenny became trustee of the Franklin Bank, an institution in financial difficulty. He ended up buying the bank in 1845 with two partners, John Groesbeck and John Culbertson, whose interests he would later purchase. The bank would stay in the family for sixty more years until it later was sold to Citizens National Bank in 1907.[24] The Franklin Bank would play an important role in Cincinnati in the mid-nineteenth century, in the era after the end of the Second United States Bank and before the Federal Reserve. This was the time when Cincinnati reached its largest size relative to other U.S. cities, and the ready supply of capital and credit by banks like the Franklin Bank played an important part of this growth. The bank was sufficiently capitalized to survive the panics that sunk a number of its competitors. Upon John Glenny Kilgour's death in 1858, Franklin Bank was the largest private bank in the city, worth $563,815, which was more than twice the value of its closest competitor.

While John Glenny's Franklin Bank played an important role in allowing the city to flourish, it was his well-timed investment in the Little Miami Railroad[25] that may have been even more important. By the mid-1800s, train transportation began to eclipse water transport as the favored and most economical method to move large quantities of goods. But the financing for the construction of the first railroads was more haphazard than any sort of well-laid plan. The Little Miami Railroad, which had been authorized by the Ohio legislature in 1836 and was headquartered in Cincinnati, was still laying track in 1839 when it became unable to finance further construction. John Glenny bought bonds to allow construction to continue, and this investment paid off spectacularly. The line first connected Cincinnati to Milford by 1841 and reached Springfield by 1846. Other railroads connected to the Little Miami, and the railway became one of the most financially successful such enterprises in the country. It also proved to be an important part of making Cincinnati a regional railroad hub that contributed to the explosive growth the city enjoyed in those days. John Glenny Kilgour became a director of Little Miami in 1842 and was president at the time of his sudden death from a stroke in 1858, at which time he was the railroad's largest bondholder and biggest shareholder. Through the Franklin Bank and Little Miami Railroad he greatly increased the money he had made from Kilgour, Taylor and Company. The *Cincinnati Daily Gazette* estimated his 1858 estate at more than $1 million.

CHARLES AND JOHN KILGOUR

Charles and John Kilgour were ages twenty-five and twenty-four when their father passed away. Charles was working for the Little Miami Railroad; John was employed by Franklin Bank. They lived with their mother downtown on Third Street in the White House. John continued the family tradition of searching for a wife from a well-off family, and he married Mary MacIntosh in 1861, who was from a prominent Georgia family and a distant relation of his mother's. When John and Charles's mother, Elizabeth, passed away in 1863, John and Mary Kilgour bought an estate, called Beau Lieu, in the heart of what is now Hyde Park. He renamed the house The Pines (See Chapter 9, The Pines), and he lived on this 156-acre property for the next fifty-one years until his death in 1914. John and Mary had two sons, Bayard and Charles, and three daughters, Mary, Charlotte and Elizabeth.

Brother Charles remained a lifelong bachelor, and he continued to live in the White House until the family sold it in 1882 to the federal government for use as a military hospital. He then moved next door into the family's Spring Hill mansion. There he would live as a recluse until he passed away in 1906, even while the near-eastern end of downtown deteriorated and Cincinnati's other prominent families moved elsewhere. In the place of this former neighborhood of mansions, factories and warehouses were built.

Charles and John's sister, Elizabeth Coles Kilgour, married Nicholas Longworth Anderson in 1865. Anderson became the youngest general to serve in the Civil War; he was a major general in the Sixth Ohio Regiment of the Union Army. Anderson's military service stands in stark contrast to the Kilgour brothers; both Charles and John avoided service during the war by paying substitutes to serve for them, a commonplace practice for wealthy men in that age.

In this preautomobile era, readily available transportation besides walking or horses was simply unavailable, and it limited the ability to develop any area not surrounding downtown. For many years, Cincinnati did not permit trains within the city limits because of the sparks (which could cause fire to wooden buildings), noise, pollution and trouble they caused to horses, often startling the animals. Horse-drawn trolleys on rail routes (railcars) were viewed as one answer to this problem. The city awarded five separate railcar franchises in 1859; the Kilgours were the successful bidders on one of these lines.

It was at this time they also began to buy large plots of farmland in today's Mount Lookout and Hyde Park. In 1872, Charles started a steam rail service along present-day Delta Avenue,[26] principally to aid in the brothers'

development of their land in Mount Lookout. Called a dummy—i.e., an engine and a passenger car all in one—this rail line operated until 1899 from Eastern Avenue to St. Johns Park, near Delta and Observatory Avenues. With the train service available, the Kilgours could sell their land in Mount Lookout for housing, as opposed to farming, at substantially higher prices than they had paid for the farmland. Many complained about the noise these dummies created, as the trains sometimes frightened the horses that others still used for transportation. Charles Kilgour was the victim of one such accident in 1872 when his horse became frightened one day and threw him, suffering a leg injury that partially disabled him for the rest of his life and contributed to his reclusive behavior.

In 1873, a number of the city's horse-car companies were consolidated with the Kilgour brothers firmly in control. The Cincinnati Street Railway Company was formed by another merger in 1880, and both brothers were directors. John was elected president of this company in 1882, a position he held for the rest of his life. He was one of the first in the United States transportation industry to electrify formerly horse-drawn trolleys, making Cincinnati one of the first American cities to enjoy electric trolley cars. Upon his death, the *Cincinnati Commercial* called him the "foremost man in America in the development of rapid transit."

By 1882, the Cincinnati and Eastern Railroad had laid its narrow-gauge tracks from Court and Gilbert Streets downtown to Hyde Park, with a small station at present-day Edwards and Wasson Avenues. Part of this railroad right of way still exists along Wasson Road that divides Oakley and Hyde Park on the northwest. Some of the area's oldest homes were constructed at this time alongside Wasson. This train line made feasible the development of Hyde Park.

Starting in earnest with John Kilgour's 1863 purchase of The Pines, the brothers came to own substantial portions of modern-day Hyde Park and Mount Lookout. The City of Cincinnati annexed Mount Lookout in 1870. In 1873, the Kilgours donated four acres and $10,000 to the city to relocate the observatory from Mount Adams to Hyde Park; it was a gesture of goodwill and a way to spark interest in their Mount Lookout development. The relocation of the observatory gave Mount Lookout its name. The Kilgours took out a large advertisement in the May 29, 1873 *Cincinnati Commercial* seeking to call attention to the new Mount Lookout subdivision they were trying to develop. The first five Mount Lookout subdivisions the Kilgours developed were on Ellison, Griest, Van Dyke, Hardisty and Halpin Avenues, near the original 1872 dummy station at the northern intersection of Linwood and Delta Avenues on the northern end of Mount Lookout Square.

John and Charles Kilgour

The brothers' most successful business development began in 1873 when Charles became interested in the telegraph. The horse accident had left him partially disabled, leading him to explore putting a telegraph in his house so he could send and receive messages there rather than having to walk or ride to businesses he owned. This in-home telegraph experiment proved successful, and John and Charles soon thereafter founded the City and Suburban Telegraph Association to set up telegraph lines throughout the area. They owned 250 of the first 400 shares of the telegraph company. The company was quite successful in its own right, but it was the investment in the telegraph lines and poles that put the Kilgours in an enviable position when the telephone was invented in 1876. Charles brought the first phones to Cincinnati in 1877 to experiment; John had the very first Cincinnati phone line, between his residence at The Pines and his Franklin Bank office on Third Street downtown. They later partnered with American Bell (AT&T) and formed the Cincinnati and Suburban Bell Telephone Company. John became president in 1901, and he was succeeded as president in 1913 by his son, Bayard. Today the company is known as Cincinnati Bell.

The Kilgour brothers began development of modern-day Hyde Park with the 1885 formation of the Mornington Syndicate. (See Chapter 3, The Mornington Syndicate Begets Hyde Park.) The syndicate members, all successful individuals before they engaged in this real estate development venture, decided that a catchier title for the district would help their development efforts. They settled upon the name Hyde Park, which they borrowed from the Hudson River Valley town north of New York City. This New York town in turn had taken the name from the 340-acre community in London, whose name dates to the eleventh century. The Kilgours were unhappy with their Mount Lookout development and the layout of Hyde Park was in part a reaction to this unhappiness.

The Hyde Park Syndicate, renamed in 1887, began the successful residential and limited commercial development of the area. The syndicate planned the central retail district and park. Their restrictive covenants mandated that houses worth at least $3,000 be built on these properties. The Village of Hyde Park was incorporated on June 22, 1896, and it was annexed by the City of Cincinnati on November 17, 1903.

The syndicate hired Myers Y. Cooper (See Chapter 8, Myers Y. Cooper: The Home Builder) to develop almost all of its holdings in Hyde Park. The Kilgours, who owned other property apart from the syndicate, also hired Cooper to develop their separately owned lands. In all, Cooper would build more than two thousand Hyde Park–Mount Lookout houses.

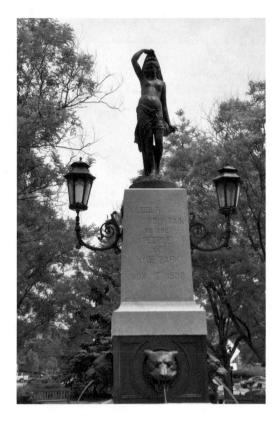

The Kilgour Fountain, donated in 1900 by Charles Kilgour, a member of the Hyde Park Syndicate. *Courtesy of the author.*

Charles Kilgour passed away in 1906, leaving an estate in excess of $8 million. He owned the controlling stock of the Miami Machine Works, shares of the Cincinnati Street Railway Company, shares of utility companies, the substantial interest in the Little Miami Railroad, one-half the interest in Franklin Bank and his vast real estate holdings.

John Kilgour passed away in 1914, leaving an estate conservatively estimated at $3 million. The *Cincinnati Commercial* noted that:

> *Mr. Kilgour was reckoned one of the very wealthy men of the City, but his life was one of unostentation, both at home and in his business affairs. With several associates he opened up Hyde Park about 20 years ago.*

The members of the board of directors of the Cincinnati Street Railway Company served as Kilgour's pallbearers.

Mary Kilgour, John's widow, gave the city five acres of land on the west side of Herschel Avenue in 1914 in Mount Lookout for the construction of

This page: John and Charles Kilgour playfully named a couple of streets after each other. *Courtesy of the author.*

the John C. Kilgour Elementary School.[27] The only proviso for the gift was that the school be named after her husband. The school was first completed by September 1922, and it has seen numerous enlargements and renovations in the ensuing years.

REUBEN SPRINGER

Springer Avenue, which runs between Delta and Grace, is named for Reuben Springer (1800–1884). Springer grew rich as a partner in the Kilgour, Taylor and Company wholesale grocery. He retired from an active business life with the dissolution of that business in 1840. In between Springer's world travels thereafter, he became Cincinnati's preeminent benefactor of the nineteenth century under the influence of his wife, Jane Kilgour Springer. At his death in 1884, he was estimated to be Cincinnati's wealthiest resident.

Springer was born in Frankfort, Kentucky, where his father was the postmaster. He succeeded his father as postmaster, but he sensed that a greater fortune was to be had in the burgeoning steamboat trade. He eventually landed a position on the steamer *James Madison*, which brought him to the attention of David Kilgour. Kilgour hired Springer in 1825 as a clerk on his steamer, *George Washington*, and Springer later became a partner in the wholesale grocery shortly after his marriage in 1830 to David's niece, Jane Kilgour. After David's death in 1830, Reuben's brother Charles married another Kilgour niece, Catherine. The partners continued the business until 1840 when Griffin Taylor, Reuben Springer and John Glenny Kilgour cashed out, leaving Reuben's brother Charles as the sole remaining owner.

After the 1840 end of Kilgour, Taylor and Company, Springer retired from active business pursuits, owing to his weak constitution. He invested his money wisely, however, making substantial sums from investments in real estate, principally downtown. Springer also invested in the Little Miami Railroad, where he was a member of the board of directors.

Under Jane's influence, the Springers began to enjoy the finer things in life, such as frequent trips to Europe, where they collected many paintings and books for a large library. Jane Kilgour was Catholic, and, in 1842, Springer became Roman Catholic as well. He was a benefactor of downtown's Saint Peter's Cathedral. The Springers, though unable to have children, were devoted to one another. Jane became paralyzed in 1858 after a coach accident and remained an invalid until her death in 1870. Reuben declined social functions during these years and instead spent his evenings with his ailing wife.

John and Charles Kilgour

After Jane passed away, Reuben became a significant donor to local causes and issues. His most well-known contribution began in the 1870s with a series of donations that totaled more than $300,000 to finance the construction of Music Hall for the May Festival, which continues to this day. There is a statute of Reuben Springer in Music Hall outside the Springer Auditorium. Springer, through his will, benefited many Catholic and secular charities, but his most well-known charity was the creation of the Springer Institute, which financed a program for local children with educational disabilities. Today, the Springer Foundation helps to underwrite the Springer School on Madison Road at Grandin Road, which serves the same purpose.

MYERS Y. COOPER

The Home Builder

The story of Myers Young Cooper (1873–1958) is an incredible American success tale. Except for the period from 1929 to 1931 when Cooper was the governor of Ohio, he spent the rest of his career from 1894 until his death building thousands of houses in Hyde Park and the eastern suburbs of Cincinnati. Starting first with the development of his father-in-law's twelve-acre farm on present-day Mooney and Zumstein Avenues south of Madison Road, Cooper thereafter built most of the houses on the land of the Hyde Park Syndicate in the triangle west of Edwards, south of Madison and north of Observatory. After he had finished this he developed most of the remaining Kilgour lands in Hyde Park and Mount Lookout.

Cooper was born the youngest of eleven children to Lemuel and Anne Cooper, who owned a small farm outside Newark, Ohio, east of Columbus. Lemuel also taught school in the winters for more than thirty years. He passed away in 1889, leaving Myers at age fifteen as the only male on the farm. Cooper ran the farm and paid off his father's debts within three years. At age eighteen, Cooper attended the National Normal School at Lebanon, Ohio, for two years, but he did not graduate. National Normal was a favorite school for those of modest means; it offered a flexible and concentrated education to provide two years of education in one by offering classes morning, noon and night. While financial concerns led Cooper to leave school and begin his career, he received from National Normal a sound—if incomplete—formal education.

At age twenty, he came to Cincinnati in 1894 to follow his three older brothers, Sanson, James and Samuel, in the real estate business. Cooper's

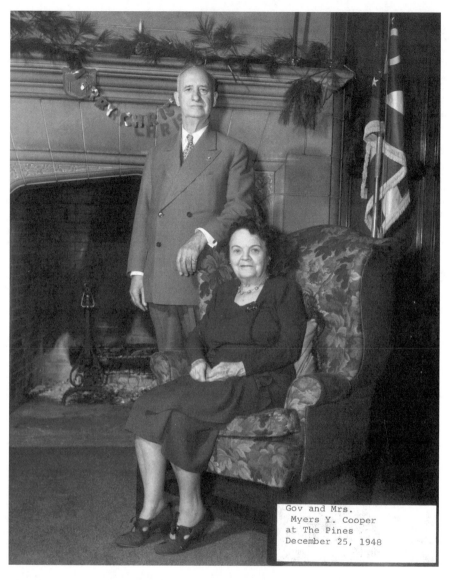

Gov and Mrs.
Myers Y. Cooper
at The Pines
December 25, 1948

Myers Y. Cooper and Martha Kinney Cooper at The Pines, Christmas 1948. *Courtesy of Randy Cooper.*

son Raymond Cooper described his father as recounting that "[h]is total capital was $16.00 and tremendous energy. Listing houses to sell and pursuing prospects were his duties. He walked from house to house all day, carrying chipped beef in his pocket for lunch."

Cooper devoted tireless energy to his real estate sales, especially in the Hyde Park area, which the Hyde Park Syndicate had actively begun to market in 1892 shortly before Cooper's arrival in Cincinnati. The four brothers went their separate ways a few years after Cooper came to town, but Cooper's efforts to sell real estate paid off almost immediately. He soon generated the capital both to build and sell homes.

Cooper attended Walnut Hills Christian Church where he met Martha Kinney, whom he married in 1897. After a sixteen-day honeymoon to Chattanooga and Nashville, the newlyweds moved in with her parents, Joel and Sarah Kinney, on January 1, 1898. Joel Kinney had served in the Union army during the Civil War, rose to the rank of major and henceforth was known as Major Kinney. He was a lawyer, living on a twelve-acre farm on

Martha Kinney Cooper, early 1900s. *Courtesy of Randy Cooper.*

the southeast side of Madison Road, between where Mooney and Zumstein Avenues are now. The Coopers had a son, Raymond, born in 1899, and a daughter, Martha Ann, born in 1902, while they lived with her parents. The Cooper family remained in the Kinney house until 1905 when they began residence at 3590 Mooney Avenue, a fine house Cooper built that still stands near the northeast corner of Mooney and Madison Road. There the Coopers lived for thirty-four years.

Cooper started the Myers Y. Cooper Company in 1895 to buy land, build houses and sell both. Cooper's wife, Martha, recounted that their marriage was of benefit both to Myers and to her father, Major Kinney, for Kinney had the twelve-acre farm that he could not sell, and Cooper had no money but had the ability to sell the land. This arrangement proved financially successful for both.

Most of Cooper's initial Hyde Park development other than the Kinney Farm, though, was with the Hyde Park Syndicate. Cooper described the start of his relationship with the syndicate and the beginning of the development of what has become Hyde Park.

> *I had sold a few lots for the Hyde Park Syndicate owning almost all the ground west of Edwards, south of Madison, North of Observatory. The arrangement was unsatisfactory with Henry Burkhold, who was Kilgours' man and who later lost out with them, and he was later succeeded by A.J. Becht. It was at this time Becht sent for me, stating he understood I did not want to handle their property. I replied "not when prices are changing with the sale of every lot." I was told to fix the price by appraising the property, and this price to stand for one year. I made this appraisal as I recall on a December day when the ground was covered with a light snow.*
>
> *These prices were recorded on a plat which we had made and this plat was signed by Charles Kilgour and myself.*
>
> *The first year sales amounted to $300,000. I bought much of the property myself and built on it. Later, Zumstein Street was made and this development was carried through both by Major Kinney and the Syndicate to the satisfaction of all concerned. I bought the block on Mooney between Erie and Observatory before the street was improved, made the street and built it up. Either through purchase or building contract I did most of the building in the syndicate property after taking over the management.*

In 1914, Cooper bought for $16,000 the Erdhouse tract, which comprised sixteen acres west of Stettinius Avenue and north of Madison Road. On this syndicate tract, starting in 1915, he built Kendall Avenue and Grovedale

Myers Y. Cooper

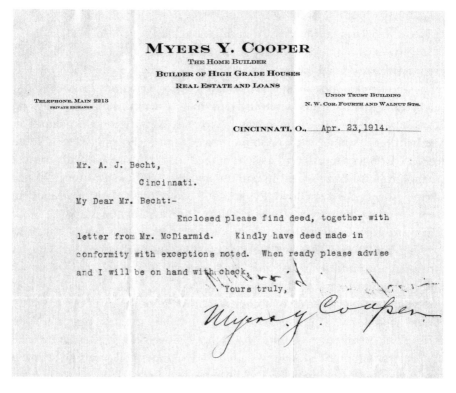

Myers Y. Cooper, the home builder. *Courtesy of the Cincinnati Museum Center–Cincinnati Historical Society Library.*

Place, and he constructed the houses that today sit northeast of Withrow High School. In 1915, Cooper bought and developed the Ben-Ve-Nuto tract from S.B. Sachs for $40,000, and on this land he built Ziegle, Monteith (north of Ziegle), Outlook and Victoria Avenues (west of Paxton and north of Erie). Cooper's next purchase was five acres at St. Johns Park, where he built twenty-five houses on and around St. Johns Place.

John Kilgour died in 1914. Cooper then bought from Bayard Kilgour Sr. in 1919 the property west of Delta to Paxton, between Erie and Observatory, for $150,000. Cooper also bought 80 acres from Bayard out of The Pines estate property, which he called Kilgour Acres and which is the property east of Paxton, north of Erie, south of Wasson.[28] (The stone pillars at the corner of Bayard and Erie Avenues have Kilgour Acres written on them.) Bayard carved out 11 acres remaining for The Pines on the land where Clark Montessori stands today; this was all that was left of The Pines estate that once comprised 160 acres.

Cooper took out a full-page ad in the *Cincinnati Enquirer* on July 12, 1919, to advertise his purchase of Kilgour Acres where he stated that "only high-class residences [will] be constructed." He did exactly that, for on this tract Cooper developed some of the most desirable houses in Hyde Park: on Raymar Avenue and Boulevard (Raymar is taken from the names of Raymond and Martha Cooper) and Victoria Avenue (east of Paxton) in 1923; Bayard Avenue and Portsmouth Avenue in 1926; and Victoria Lane in 1928. Cooper's fourth purchase from the Kilgours was $130,000 for most of the property they owned in Mount Lookout. For this venture, Cooper partnered with R.K. LeBlond, founder and owner of the LeBlond Machine Tool Company in Norwood, where Rookwood Pavilion now stands.

Bayard Kilgour next sold Cooper forty acres known as Sugar Hill, east of The Pines, for $152,500. This area included the land zoned for business and houses around the horseshoe bend on Erie Avenue. By 1917, Cooper had built more than one thousand homes in Hyde Park. By 1928, he had built another one thousand homes in the neighborhood. The *Cincinnati Enquirer* noted that "Mr. Cooper and his family had changed pastoral Hyde Park into a prospering Cincinnati neighborhood through their enterprise and determination." Before he was finished, Cooper built more than seven thousand homes in Hyde Park, Mariemont and throughout the eastern suburbs of Cincinnati. At one point Cooper was the sole realtor for Marie Emery for the Village of Mariemont that she founded.

Cooper's home building seized on the principles of vertical integration—he could build an entire house with contractors from companies he owned or controlled and he could finance it, too. In addition to his ownership in the Myers Y. Cooper Company, he founded the Hyde Park Lumber Company, the Hyde Park Supply Company, Midland Lumber Company, Cincinnati Building Supply, the Westwood Planing Mill, King Heating and Roofing (later King Heating and Air Conditioning), the Raymond Realty Company and the Standard Castings Company. He also was a founder of the Hyde Park Savings Bank—the name of the bank is still visible on the facade of the building at 2710 Erie Avenue on Hyde Park Square. Cooper also was the president of the Norwood National Bank, which later was consolidated with the Hyde Park bank into the Norwood-Hyde Park Savings Bank and Trust Company. Cooper was president of this bank until 1954, when he became chairman of the board, a position he held until his death in 1958. This bank eventually was sold to the Fifth Third Bank.

Cooper was a forerunner in selling houses by mortgaging them in return for monthly payments. A biographer tells the story that:

Myers Y. Cooper

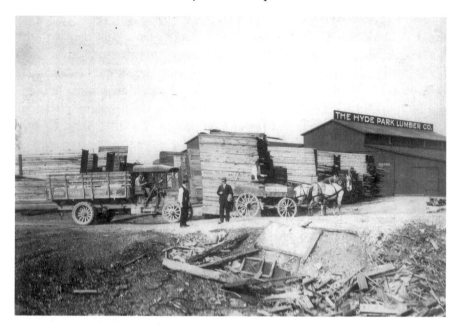

Cooper started a number of businesses, including the Hyde Park Lumber Company, which remains in family hands today. *Courtesy of Mike Judy.*

[Cooper] *had reached the conclusion that many honest and industrious working people who desired to own homes and could pay for them in due time were denied this privilege because it was customary to ask for one-third of the purchase price in cash. To meet this situation and to broaden the scope of his business, Cooper in selling the houses which he built developed a new type of financing plan. This required a small down payment, a first mortgage based on sound values, and a second mortgage for the balance. He was careful to ascertain before making the sales that the purchaser was of good character and could pay both the first and second mortgages within his financial income. The total family earning capacity was given due consideration. His judgment in this matter has been amply justified by the fact that he has never had a mortgage foreclosure. This financing plan, which proved successful in Cincinnati, has been adopted in broad outline in all parts of the United States and has greatly stimulated home ownership.*

Cooper's son, Raymond, and his son-in-law, Mills Judy, joined his businesses after they graduated from Yale. They helped Myers construct the Cooper Building on the southwest corner of Erie and Edwards Avenues

on Hyde Park Square. Raymond "R.K." Cooper later built the two-story building across Erie on the northwest corner of Erie and Edwards to house the headquarters of the Myers Y. Cooper Company. They also took possession of the Burch Flats—today renamed the Mills Judy building— on the northeast corner of Erie and Edwards. Today Raymond "Randy" Cooper II runs the Myers Y. Cooper Company and Mills "Mike" Cooper Judy Jr. runs the Hyde Park Lumber Company.

In 1939, Cooper's final purchase from the Kilgours was The Pines itself, at 3030 Erie Avenue, which he bought for $67,500 from Mary Andrews Kilgour, Bayard's widow. Cooper moved from 3590 Mooney Avenue to The Pines, which was home to the remaining 11 acres of the estate that once covered 160 acres. Myers and Martha Cooper took possession on October 15, 1939. Cooper's description of his financing of The Pines is of interest:

I paid [Mary Kilgour] $25,000 in cash and agreed to pay the balance on or before Jan. 10th, 1942, with 3% interest. After having reduced the amount to $22,500 I borrowed this amount from The First National Bank in August of 1940 and paid Mrs. Kilgour in full, accepting the deed. I made payments on the Bank notes from time to time completely clearing this debt by the final payment of $8,500 on Nov. 27th, 1941, celebrating the event appropriately by taking my wife to the Netherland Plaza for dinner and to a movie.

The Pines was not the only grand Hyde Park estate that Cooper bought. In 1950, eleven years after he bought The Pines, Cooper bought the last fourteen acres of the Rookwood estate and the Rookwood house itself from Alice Roosevelt Longworth, daughter of President Theodore Roosevelt and widow of Speaker of the House Nicholas Longworth. Nicholas Longworth's grandfather, Joseph Longworth, reputedly one of the richest men in the West at the time, had purchased the one-hundred-acre Rookwood estate in 1848.

The *Cincinnati Post* published a poignant piece on Cooper's acquisition of the remnants of the estate.

The former governor, Myers Y. Cooper, was feeling a bit sad, in a philosophical way, as he surveyed the historic estate of which he has just become the master. The governor's mind was on the way the things of earthly grandeur pass.

"I think of a dynasty going," he said as looked upon the mortal remains of Rookwood, on Grandin Road, which through 102 years had been the

home of the generations of the Longworths...Longworth I, Longworth II and Longworth III, who was the Cincinnati congressman and speaker of the House of Representatives when he died in 1931.

Mr. Cooper had just bought, by way of his function as real estate broker and builder, the 14 acres that were left of the Longworth estate on Grandin Road. Mr. Cooper, as the new owner of Rookwood, was himself a most distinguished exemplar of the American process. When the Longworths were long established at Rookwood, like their giant oak trees, Mr. Cooper was a struggling young builder hereabouts.

Now, as the new owner, Mr. Cooper was looking at fortune with sincere humility. He was going to cut up the Rookwood estate into spacious lots on which he would build elegant homes. He looked up at the great oaks. He would reverently protect them.

The Longworths previously had sold about ninety acres of the one-hundred-acre tract that is today the Rookwood subdivision of Hyde Park, near the Cincinnati Country Club on Grandin Road.

Cooper's development efforts extended for a brief time to Coral Gables, Florida, as well. Winter home construction in Cincinnati can be problematic, and Cooper had a significant number of skilled trade and craft employees who were unemployed or underemployed during these periods of cold, snow and ice. For a time, this issue was solved due to the efforts of the American Building Corporation that was formed in 1923. The owners of the ABC were some of Cincinnati's business titans,[29] and they contracted with Cooper to construct a number of large homes in the new development of Coral Gables. The efforts of ABC came to a screeching halt after a hurricane in September 1926 destroyed substantial portions of Coral Gables. As a result, the owners of the American Building Corporation lost most of their money in the venture; they lost their interest in seeing this venture through, as well. The money still owed by ABC to Cooper was settled by giving title to eleven houses to the Myers Y. Cooper Company, which Cooper later sold. He maintained a winter house in Coral Gables at the corner of Cottoro and Leonardo.

Cooper's father was a Republican, and for many years Cooper was active in Republican Party politics. He campaigned for William Howard Taft's successful run for the presidency in 1908 but joined Theodore Roosevelt's Bull Moose movement in 1912. He returned to the Republican fold in 1916, where he stayed for the rest of his life. With the exception of 1928, Cooper attended the Republican national convention every four years

beginning in 1916. He had become well-known throughout the state of Ohio through his eleven years of service as president of the Ohio Fair Managers Association and three terms as president of the Ohio Council of Churches. In 1926, Cooper won the Republican primary for Ohio governor, but he lost in the general election to the incumbent governor, Vic Donahey, by only seventeen thousand votes. Two years later, Donahey did not run, and Cooper was chosen as the fifty-first governor of Ohio, elected along with a tidal wave of Republicans—a Republican was placed in every statewide office that year.

Cooper served as governor from 1929 to 1931. There was pent-up Republican demand from previous legislative sessions, given a Republican legislature and a Democratic governor. The General Assembly met from January 15, 1929, to April 16, 1929, and it passed 222 bills; Cooper vetoed 22. Cooper's agenda became law and among the principal reforms were: repeal of the act permitting public utilities to put new rates into effect without approval by the public utilities commission; strengthening the state's

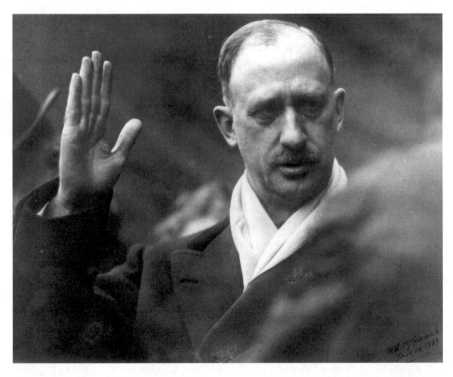

Cooper taking the oath of office as the fifty-first governor of Ohio, January 14, 1929. *Courtesy of Randy Cooper.*

Myers Y. Cooper

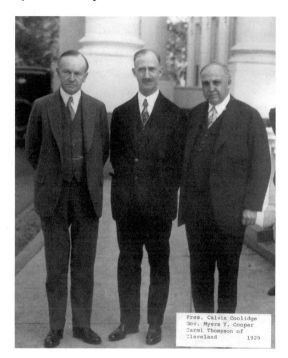

Right: Cooper at the White House with President Calvin Coolidge (left) and Cleveland mayor Carmi Thompson (right). *Courtesy of Randy Cooper.*

Below: Governor and Mrs. Cooper with Charles and Anne Lindbergh, statehouse, Columbus, 1930. *Courtesy of Randy Cooper.*

Pres. Calvin Coolidge
Gov. Myers Y. Cooper
Carmi Thompson of
Cleveland 1929

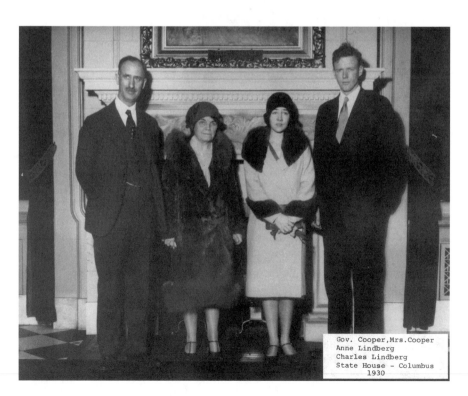

Gov. Cooper, Mrs. Cooper
Anne Lindberg
Charles Lindberg
State House - Columbus
1930

"blue sky" securities laws; revision of the general corporation act; revision of the code of criminal procedure; strengthening the election laws; enactment of a law for the conservation of natural resources; and strengthening the state's banking laws. Cooper worked diligently on behalf of the citizens of Ohio. One commenter noted that "[t]here were competent observers who called Cooper 'the hardest-working governor the state ever had.' Certain it is that no governor gave more of himself through long and arduous hours than this governor."

Cooper was the last governor before the Great Depression, when economic calamity greatly increased the demand for governmental services. But even during Cooper's governorship, state government had substantially outgrown the building and office space available in Columbus. Cooper worked on construction of a new building, and a site was chosen between Broad and Town Streets and between Front Street and the Scioto River. The building ultimately was completed by March 30, 1933, at a cost of $5.6 million (which included $1.4 million for the site). Cooper's efforts were well regarded.

The *Columbus Dispatch* stated that:

> *Governor Myers Y. Cooper has given to Columbus the greatest lift ever extended to it by a governor... Other Governors have failed to bring the plans for a state office building to completion; Governor Cooper's administration made this project, which will mean so much to the future and beauty of Columbus, a reality. Every man and woman in Columbus regardless of political connections should feel they owe a great deal to this man. If we are loyal to Columbus and have a proper sense of gratitude we will give to Governor Cooper all our votes in November.*

However, continued growth of state government by this time meant that the state government was already out of room again by the time the state office building was complete.[30]

The low point of Cooper's administration came on the Monday after Easter, April 21, 1930. The state penitentiary was undergoing renovation to construct new fireproof cellblocks; wooden scaffolding was erected for this construction. Four inmates set fire to the scaffolding to create a diversion in order to escape. But the wooden roof of one cellblock caught fire, and 332 men were suffocated and lost their lives. The guilty men were identified; two committed suicide, the other two were sentenced to life imprisonment. However, the fire did provide the impetus for construction of new state

prisons, due to prison overcrowding that the prison's warden had urged the General Assembly to do each year since 1921. But it took the General Assembly fifteen years to appropriate these funds.

During his administration the Martha Kinney Cooper Ohioana Library was created, intending to house the works of Ohioans. Martha Cooper maintained her interest in this project until her death, hosting any number of Ohioana affairs at The Pines.

The Great Depression, which started in the fall of 1929, was a death knell to incumbents in 1930 and this caught up with Cooper, who was handily defeated in his bid for re-election by George White in a year when Republicans stayed away from the polls. An editorial in the Toronto, Ohio, *Tribune* summed up the causes for Cooper's loss.

> *That Ohio Governor Cooper was defeated in the Tuesday election is no real surprise to those who closely follow Ohio elections. In twenty-nine years no Republican Governor has succeeded himself. It seems the Republicans get tired of a Democratic state administration and elect a Republican... Then in some self-satisfied way just go to sleep in the next campaign; and go down to defeat under a barrage of destructive criticism. Governor Cooper has given to Ohio, in our opinion, the most business-like administration Ohio has ever enjoyed. He stands defeated by his own party[.]*

He ran again in 1932 for governor but was defeated in the Republican party primary by David S. Ingalls of Cleveland, who in turn was defeated by Governor White.

Cooper never again sought elective office, but he did continue to serve in a number of political and civic organizations. Beginning in 1933, he served as chairman of the Little Miami Conservancy District. In 1936, he served as a member of the national Republican campaign staff. From 1938 to 1941, he was chairman of the committee on real estate taxation of the National Association of Real Estate Boards. Governor Thomas Herbert appointed him in 1947 and 1948 to chair a commission to select a new site for the Ohio Fairgrounds. From 1949 to 1951, he served as a member of Ohio's Little Hoover Commission, which prepared a report for the state to consider for administrative improvement and reform.

Myers and Martha Cooper returned to Hyde Park, the last owners to occupy the historic estate of The Pines. Myers passed away on December 6, 1958, at age eighty-five, and Martha died on April 20, 1964, at age ninety. The Pines was left to their children, Raymond K. Cooper and Martha Anne

Cooper Judy. The decision about what to do with the property was made for the Cooper children when the Cincinnati Board of Education bought the property from them after initiating eminent domain proceedings to build a new junior high school, the Walter Peoples Middle School. Today, this property is the Clark Montessori School.

CHAPTER 9

THE PINES

The Pines at 3030 Erie Avenue was the 21-room grand mansion and 160-acre estate of Hyde Park founder John Kilgour, but it has been gone since 1966. It was located in the heart of Hyde Park proper, bordered by present-day Wasson and Observatory Avenues to the north and south and by Paxton Avenue and St. John Place to the west and east. Purchased for $106.00 by Thomas Wade, one of the original settlers of Cincinnati, today the original 160-acre tract is home to more than 250 houses, a school and 3 churches. A conservative estimate of the (improved) value of the land today exceeds $135 million.[31]

On April 1, 1795, Revolutionary War veteran Wade bought the tract that would later become The Pines. Wade had arrived with the very first group of Cincinnati settlers who landed near the confluence of the Little Miami River and the Ohio River on November 18, 1788. In the area known as Turkey Bottoms, the settlers started a community they called Columbia, which years later became a part of Cincinnati. Forty days after these settlers arrived, others followed to found Losantiville, later renamed as Cincinnati.

Wade was among the founding fathers of the Columbia Baptist Church, organized in January 1790. The church's original graveyard is now known as the Pioneer Cemetery, across from Lunken Airport on Wilmer Avenue. Wade's church relocated in 1808, first to Oakley and then to Duck Creek and Mount Lookout before settling down as the Hyde Park Baptist Church at the southeast corner of Erie and Michigan Avenues, where it remains today. This is the oldest church in the Northwest Territory.

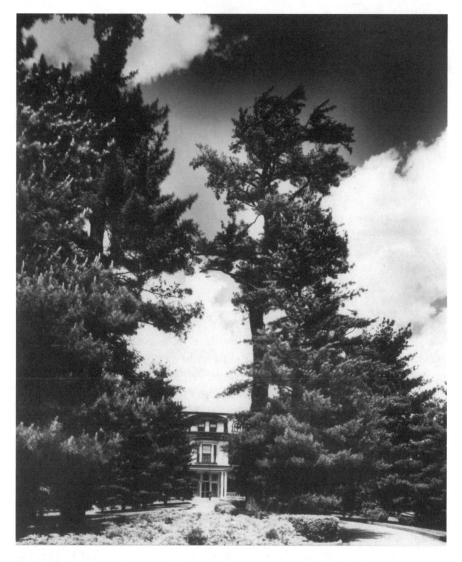

Pine trees, 130 years old, tower over The Pines in the 1950s. *Photo by Paul Briol. Courtesy of Mike Judy.*

Wade himself took a more direct path to Hyde Park. Columbia's problems with flooding and Indians had apparently convinced him to make his way up the hill away from the rivers by 1795. On the 160-acre tract where some of Hyde Park's finest homes now sit, he built a simple house and farmed the land.

Wade sold the house and property in 1806 to the minister of his church, Rev. William Jones. Wade became one of the first Hyde Park landowners

to turn a tidy profit on the sale of land, as he sold the tract for $1,000—
he made almost ten times his initial investment in eleven years. In addition
to performing his pastoral duties, Rev. Jones farmed the property until he
moved to Springfield, Ohio in 1818. Jones, too, made a decent sum on the
property when he sold the farm to James Hey for $5,000.

It was Hey who turned the simple farm into a country estate, which he
named Beau Lieu Hill Farm (French for Beautiful Place). Hey, an Englishman,
made his fortune in the East India trade. He left his native country, became
enchanted by the charms of the Queen City and put down roots on this
farmland just five miles from the bustling new city of Cincinnati. Hey built
a three-story gentleman's country house approximately where the Clark
Montessori School presently sits. Much of the working farm was converted
to hedges and flower gardens. A long driveway stretched from what is now
Observatory Avenue (then City Road) north to the house; rows of evergreens
that lined the drive remained in existence until the state bought what was left
of the estate in 1965. Hey built stables, raised horses and hounds and hired
a hunt master to help him entertain his friends on fox hunts. Legend has it
that Hey left England after being jilted by a woman. Hey built a high brick
wall around the home high enough that no woman could see over. Kilgour
took down the wall when he bought the property years later.

Hey, a bachelor, passed away in 1845. He was buried on the estate between
two giant oak trees at the highest point of the property on what is now 3521
Bayard Avenue. These mighty oaks still stand today. Hey left Beau Lieu to
a favored nephew, Benjamin Hey, who sold the property in 1848 to Rukard
Hurd for $28,000.

Hurd was a successful downtown dry goods merchant, operating a store
at Fourth and Race. He plowed his profits into downtown and suburban real
estate, including Beau Lieu. A later description of the property concerning
the period when Hurd lived on the estate is of interest:

> *The Hurd homestead was "Beau Lieu" (Beautiful Place), on Indian Hill
> just out from the noise of the town. An English gentleman named Hey…
> built a mansion after the old English architecture, on a magnificent hill
> commanding a view seldom equaled for beauty and grandeur. The house
> was surrounded with 160 acres of noble trees and beautiful drives and
> parks, winding in and out among beautiful gardens hedged with boxwood.*
>
> *The fields were hedged with Osage orange and English hawthorn.
> There were stables, a conservatory and a wine cellar stocked with rarest
> wines at a cost of $40,000; a great orchard of finest apples trees and a*

cider mill. Within the home was all that could be desired in those days for luxurious living.

The furniture was massive and beautiful in its simple elegance. The library contained the choicest works of the masters in literature, comprising many rare works in French and German. The servants' quarters, on the ground floor, contained dining and sitting-rooms, and there, amid this luxury, Mr. Hey died…Rukard Hurd delighted in his library, was a lover of books and spent his later years among his books, his gardens and fields.

Hurd sold Beau Lieu to John Kilgour in 1863 for $45,000. Kilgour, just twenty-nine years old at the time, later was the initial driving force behind the development of Hyde Park. He renamed the property The Pines, and he lived there until he died fifty-one years later in 1914. Kilgour quickly and substantially changed the property. An 1870 account of The Pines is remarkable for its description of the swift change in the property:

Many will, at the mention of these premises, recall the memory of James Hey, the eccentric Englishman who came to this place forty years ago and improved the farm that is now the delightful home of Mr. Kilgour. On reaching the gate, one looks up in the direction of the building through a vista of cedars planted by this singular bachelor on either side of a graveled drive. The sides are thickly studded with these living columns, whose aged branches now arch the roadway and twine themselves about each other, forming a perpetual shield from both sunshine and storm. In front of the dwelling, which is several hundred yards from the road, are pines, planted by the same hand, some of them two and a half feet in diameter and sixty feet in h[e]ight. The old dwelling has been so changed by Mr. Kilgour that its former self is scarcely discernible. A Mansard roof has been added; verandas, like those of the south, sweep around three sides of the building; while other improvements have so transformed the beau ideal of the Englishman's home that now he would scarcely recognize it, could he revisit the home of his former labors.

Kilgour kept the estate intact with but a few exceptions. In 1879, Kilgour leased a narrow strip across the northern part of the estate to the Cincinnati and Eastern Railroad. The railroad purchased this land in 1891, and a rail line remains on this property to this day, immediately south of what is now Wasson Road. More significantly, in 1893, Hamilton County won eminent domain rights to buy and construct Erie Avenue through the

The Pines

Right: Front porch of The Pines, 3030 Erie Avenue. *Photo by Paul Briol. Courtesy of Mike Judy.*

Below: Front of The Pines, overshadowed by 130-year-old trees. *Photo by Paul Briol. Courtesy of Mike Judy.*

middle of the estate, first for use by street cars and later for use by motorized vehicles. Kilgour did not develop the strip between Erie and Observatory, so passengers on the streetcars passed through the heavily wooded fields on either side of Erie Avenue. The only other significant alteration to The Pines tract while Kilgour inhabited the house was sale of the land for Grace Avenue, between Erie and Observatory. At Kilgour's death, 145 of the original 156 acres remained.[32]

Kilgour's widow transferred the property in 1915 to her son, Bayard Kilgour Sr., who made substantial interior and exterior updates to the house. Bayard began in earnest the sell off and residential development of the property surrounding the house; from 1914 to 1939 the estate was reduced from 156 acres to 11. Delta Avenue, which begins nearly at the Ohio River, originally ended at the south end of the Kilgour property at Observatory. Bayard sold the land to allow Delta to be extended one block to Erie. He then sold nearly 7 acres east of Delta to Myers Cooper, who developed twenty-five houses on this 7-acre site, principally on St. John Place. John Kilgour earlier had whimsically named St. Charles Place, several blocks west of The Pines, after his older brother Charles. Cooper returned the favor for Charles, and St. John Place was named for brother John.

Bayard Kilgour sold off the prime lots between Erie and Observatory and Delta and Paxton beginning in 1919 to Cooper, and he later sold additional land to Cooper, who became the governor of Ohio from 1929

Courtesy of Roger F. Weber.

to 1931. Cooper was one of the driving forces behind the development of a substantial part of Hyde Park. On The Pines estate, Cooper began development of Raymar (named for Cooper's children, Raymond and Martha) and Victoria[33] Avenues in 1923, of Bayard Avenue in 1926, and Portsmouth Avenue and Victoria Lane in 1928. Cooper notes that he paid John and Bayard Kilgour more than $600,000 for their land that he developed. After Bayard passed away, his widow, Mary Andrews Kilgour, sold the mansion and the remaining eleven-acre estate to Cooper in 1939.[34] She sold the property and house for $67,500, which was less than she had been offered by others, out of gratitude to Cooper for his fine development of the acreage surrounding the house.

Cooper lived in The Pines for his last nineteen years, from 1939 to 1958, while he continued his Hyde Park development efforts through his Myers Y. Cooper Company that he had founded in 1905. Cooper's widow, Martha, lived in the mansion until she passed away in 1964.

At eleven acres, The Pines was one of the last substantial properties in Hyde Park or Mount Lookout in 1964 available for development. The Cincinnati

Parlor of The Pines. *Photo by Paul Briol. Courtesy of Mike Judy.*

The handsome wood-paneled library of The Pines. *Photo by Paul Briol. Courtesy of Mike Judy.*

Board of Education was running out of room at Withrow High School for junior high students, and it eyed The Pines property as a place to locate a junior high. The Cooper children opposed the school development, as they wanted to develop new houses on the remaining property. This led to another Hyde Park property dispute, for which the neighborhood has been (in)famous since its founding. One writer observed that "[n]ot since Civil War soldiers tramped up and down the tranquil Virginia hills has there been such a struggle on such peaceful grounds as The Pines, an 11-acre estate at 3030 Erie Avenue." More than four hundred Hyde Park neighbors rallied in opposition to the school board's plans. The Cincinnati Planning Commission opposed the school development. The *Enquirer* came out against the school development, in part because "[s]till, we think that Cincinnati has too few beauty spots already and that it can ill afford the loss of The Pines—even for so worthwhile an undertaking as a school." But the board of education decided to put the new Hyde Park junior high on the site, and it bought the property from the Cooper children in November of 1965 after it had started eminent domain proceedings.

The Pines

One of the rear gardens of The Pines. *Photo by Paul Briol. Courtesy of Mike Judy.*

The Pines was razed on December 20, 1966, and Walter Peoples Middle School was constructed in its place. The school was built in 1967 and 1968 and was later razed in 2009. On the site of the great Hyde Park estate, a new school building is being constructed by the board of education in 2010 for the Clark Montessori School.

HYDE PARK SQUARE

H yde Park Square is the heart of Hyde Park. The square is just one block off Erie Avenue bordered by Edwards Road to the west and by Michigan Avenue to the east. The grassy boulevard in the middle of Erie Avenue has been there from the beginning and the Kilgour fountain since 1900. The last of the four corner buildings on the square was completed in 1908 and the remainder of the buildings between Edwards and Michigan present today were finished by 1932. Graeter's Ice Cream, the Echo Restaurant, the Castle House children's clothing store and Arthur's Restaurant are the four longest-lived tenants of the current bunch. And as anyone knows who has tried to find parking on the street, there never has been enough of it.

Hyde Park is to some extent a planned community: There was to be no industry. The shopping and business district was to be located in and around the planned Kilgour esplanade (later Hyde Park Square), and the remainder of the community was to be upscale residences, churches and schools. This original plan has largely been fulfilled.

THE FOUNTAIN AND THE PARK ON THE SQUARE

John and Charles Kilgour donated the land in the middle of Erie Avenue to be a park in the center of the business district today known as Hyde Park Square; originally it was called the Kilgour Esplanade. The Kilgours were

wealthy before they started development efforts in Hyde Park with the Hyde Park Syndicate, and they generated jealousy and resentment due to state-funded public improvements such as roads, water lines and gas lines that some perceived unduly benefited their new development. These ill-feelings also were stirred up by the configuration of the railcar tracks the Kilgours placed on Erie Avenue, which some disliked, for the electric trolleys of the Cincinnati Street Railcar Company. In order to ameliorate some of these feelings, Charles Kilgour commissioned sculptor Joseph F. Cronin to design the fountain in the middle of the square, and the fountain—a stone column topped with a female figure, flanked by two lanterns and four lion heads—was dedicated on November 6, 1900, as a gift to the people of Hyde Park.

The grass and shrubbery-lined boulevard in the middle of the square originally stood at street level. In 1916, at a cost of $2,200, a bandstand was constructed at the east end of the park. It lasted until 1935. In 1917, the square came under the domain of the Cincinnati Park Board, and, in 1926, the square was raised about three feet and rows of trees were added to either side and to both ends. The drinking fountain was added in 1947, dedicated by the Hyde Park Business Association to those neighborhood residents who lost their lives during World War II fighting for their country.

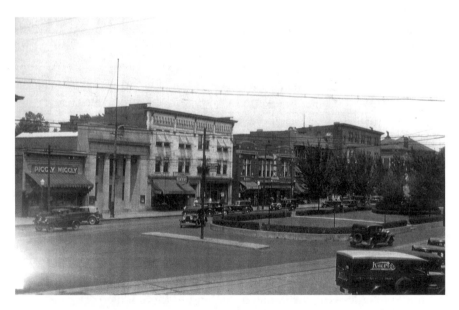

Hyde Park Square, looking northeast, from the 1920s. The Hyde Park Town Hall is barely visible at the top right. *Courtesy of Mike Judy.*

The flagpole was dedicated by Mills and Martha Judy in 1980 in honor of Myers Y. Cooper, the Hyde Park homebuilder who built many of the houses in Hyde Park and who served as Ohio governor from 1929 to 1931.

After seventy-five years of use, the Kilgour Fountain no longer was operative by 1975. The neighborhood and the park board together raised $25,000 to completely rehabilitate the fountain, and it was rededicated in 1976. But this overhaul needed its own fix by 2003, as there were plumbing failures, electrical problems, corrosion and a deteriorating concrete water base. The Cincinnati Park Foundation raised $221,000 from almost five hundred donors to fund the renovation that cost $171,000 and was complete by the end of 2003. The balance of the funds was used to create an endowment to fund future repairs.

The City of Cincinnati spent nearly $1 million in 2003 to give the square a facelift that included access for the disabled to the square as well as a new streetscape, moving utility lines underground and redoing the sidewalks and parking on the square and in the areas near the square. The city removed and replaced a number of the trees on the square, which generated both praiseworthy and blameworthy reactions. Jane Sanders, president of the Hyde Park Business Association, said the 2003 renovations made the square into "something even more gorgeous. I don't think there's a business district in the country that's any better or prettier. It's spectacular." But Carl Uebelacker, a Hyde Park resident for more than twenty years, had a different opinion. He stated that "[t]hey took a classical, turn-of-the-century square that had a unique character to it and did a radical makeover that looks like what you can see at any suburban mall. It's a crying shame."[35] The new trees appear to have matured as the city planners had envisioned, however, and the square has continued its gradual evolution over time into a still-lovely park today.

THE BUILDINGS AND THE RETAIL

The Burch Flats at 2702 Erie Avenue—today the Mills Judy Building—was the first building completed on the square, finished in 1890. Graeter's has been a tenant since 1938, and the Echo has been a tenant since 1947. Immediately south of the Mills Judy Building, the five-story, sherbet-colored apartment building, Al'Aise, at 2713 Erie, was completed in 1903. Catter-corner from those apartments, the Virginia Flats apartment building at the northwest corner of Erie and Michigan, 2728 Erie, was finished in 1905.

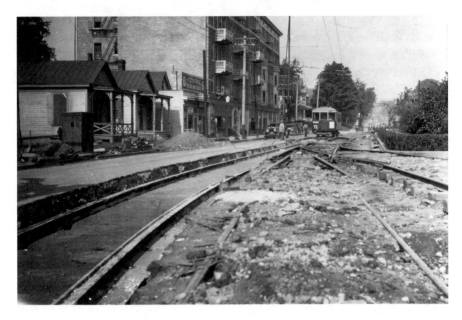

Erie Avenue looking west, being torn up to replace the trolley tracks. Note the dwellings on the south side of the square in this 1927 photo. *Courtesy of the Cincinnati Museum Center– Cincinnati Historical Society Library.*

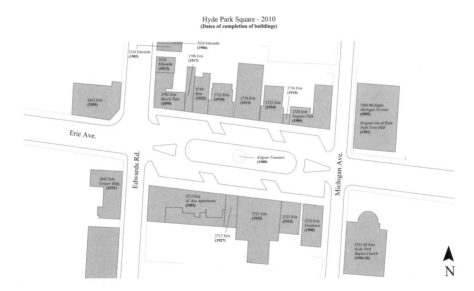

Courtesy of Roger F. Weber.

The firehouse for Engine Company Forty-six was dedicated in a grand ceremony on July 18, 1908.

The square on Erie was not always entirely retail. A 1917 Sanborn fire map shows four narrow houses on the south side of the square at 2717, 2719, 2721 and 2723 Erie that were present until at least 1927. This same map shows dwellings on the southeast side of Edwards Road, immediately south of the Al'Aise apartment building. All of these houses are long gone, replaced with retail buildings.

The middle six buildings on the north side of the square were completed between 1910 and 1922: 2708 Erie, originally a grocery, was finished in 1917; 2710 Erie, the Hyde Park Savings Bank, was built in 1922; 2712 Erie, a dress shop and five-and-dime, was finished in 1910; 2718 Erie was finished in 1913; and in 1910, both 2722 and 2726 Erie (the very small retail outlet) were complete. On the south side of the square, there are only three interior buildings: 2717 Erie was completed in 1927; 2721 Erie was finished in 1932; and 2727 Erie, the Peebles Flats, was complete in 1915.

As for the four corners immediately adjacent to the square on Erie, the three-story Hyde Park Town Hall, at 2740 Erie Avenue, on the northeast corner of Erie, was dedicated on December 12, 1901. That building was torn down for a service station in 1960, but today this space is the Michigan Terrace Condominiums. Going south across Erie, the Hyde Park Baptist Church was finished in two parts between 1904 and 1926. On the southwestern end of the square at Erie and Edwards, the five-story Cooper Building was completed in 1931 by the Myers Y. Cooper Company. Initially it housed the corporate offices for the governor's building company as well as for other tenants. After the governor's death in 1958, his son, Colonel R.K. Cooper, built the two-story building on the northwestern end of the square at 2652 Erie into which he moved the corporate offices of the Myers Y. Cooper Company.

Some residents of Hyde Park may tend to think that the neighborhood— and the square especially—are immune to change, but this is not the case. The retail on the square from earlier days was very different than it is today. The 1962 opening of the Hyde Park Plaza after a four-year court battle[36], and the 1993 opening of Rookwood Pavilion,[37] have had a substantial effect on the retailers on the square. A 1940 study of one of the buildings on the square cataloged the square's retail shops. Seventy years after this study, the Graeter's ice cream store is the only tenant remaining in 2010 that was there in 1940. Other tenants on the square in 1940 included two dry cleaners, a hamburger shop, an independent grocery, two chain groceries, a five-and-

dime, a women's clothing store, two drugstores, a hardware store, two fruit markets, a meat market, a bakery, a shoe store, the post office and a shoe store. But for the women's clothing store, there is not a single specialty shop among them.

The square over the years has had a number of longtime tenants, a few of which remain. The Castle House, home for children's clothes, has been on Edwards Avenue since 1965. Some departed tenants of note include Kroger's, at 2721 Erie, and Piggly Wiggly, at 2708 Erie. Other retailers long gone from the square include Hickory Farms, which was a tenant from 1962 to 1978, and the Hyde Park Movie Theater, which operated for many years at 2718 Erie until it closed in 1983. The Carriage Trade, which carried unique women's apparel, jewelry and other gifts, was a tenant for thirty-nine years at 2708 Erie until it closed in 1997. Gattle's fine linens and lingerie was a tenant in the Michigan Avenue shops owned by the Hyde Park Baptist Church for a number of years until it moved to Montgomery in 2001, largely in search of more parking. But perhaps the most unique Hyde Park Square tenant of all was WEBN-FM radio station, which broadcast from 2722 Erie Avenue from 1973 until the station was purchased by Jacor in 1986 and moved shortly thereafter to Mount Adams.

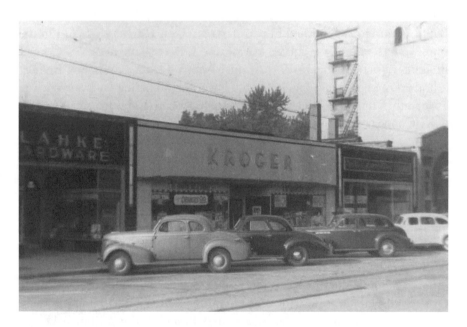

The Erie Avenue Kroger store, circa 1940. *Courtesy of Mike Judy.*

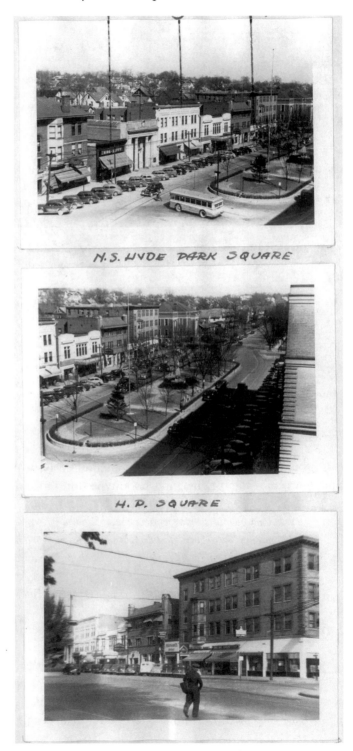

Photos of Hyde Park Square from 1940. *Courtesy of Mike Judy.*

North side of the square, looking east. The movie theater and the 1901 Hyde Park Town Hall, which was razed in 1960, are visible here. *Courtesy of Mike Judy.*

One commenter observed the phenomenon thirty-two years ago that the square was moving from neighborhood-type stores to specialty stores:

> *"Hyde Park Square is changing from a neighborhood serving center with day-to-day services like cleaners, hair dressers and drug stores to a regional serving center with more than half the stores specialty shops," said Carl Uebelacker, president of the Hyde Park Residents Association. "They (specialty shops) are driving out the neighborhood services into the (Hyde Park) Plaza."*

A similar sentiment was echoed in a 1983 newspaper review.

> *Hyde Park Square, with its pastel, arch-windowed shop block, central esplanade and bubbling fountain, is the neighborhood business district of everybody's dreams. Quaint, pretty and old-fashioned, it has enough of a small town feeling for a neighborhood and enough urbanity for a city.*

Hyde Park Square

It's a place where Hyde Parkers can count on running into their neighbors on the street and where merchants and their customers are on a first-name basis. It's still a place where you can buy fresh vegetables, children's shoes, do your banking, and have prescriptions filled by a druggist who remembers your last bout with the flu.

But it has ceased to be a place where a housewife can buy the weekly groceries, pick up a spindle of thread or replace frayed stockings. It's a neighborhood business district that has become too specialized to serve all the neighbors' daily needs.

"It's one of the neighborhood business districts that's almost too successful," explained Steven Bloomfield, director of Cincinnati's Department of Neighborhood Housing and Conservation.

Hyde Park, which now caters to the luxury trade, is the prime example. Fancy dress shops, jewelry stores and chic restaurants have replaced the old five-and-dime, the supermarket, two mom-and-pop groceries and the drugstore with a soda fountain.

In 2010, the square is home to a half-dozen restaurants, from a diner on one end to a latin restaurant on the other, men's and women's clothing shops, accessory and gift stores, jewelry stores, women's shoe stores, banks, realtors, an eyeglass shop, post office, coffee shop, lingerie shop, rug store, soap shop, dry cleaner, children's clothing shop, stationery shop, art galleries, a fine wine and cheese store, antique jewelry store, an upscale pet shop and a fire station.

THE PARKING PROBLEM

Since the streetcars stopped rolling through Hyde Park in the 1950s, and since the ever-increasing popularization of the automobile, Hyde Park Square has simply lacked sufficient parking to accommodate the needs of those who would patronize the square's merchants. This may have been the biggest flaw in the late 1880s design of the square (which obviously predated the automobile).

One plan floated by the city traffic engineer and planning commission in 1958 was to condemn and demolish nine houses immediately north of the square on Edwards Avenue and on Michigan Avenue to form part of a large parking lot. Another part of this plan was to buy the Hyde Park Evangelical United Brethren Church at 2753 Erie Avenue, demolish it and put a parking lot there as well. Area merchants initially indicated a willingness to be assessed

to finance the purchase of the church and these houses, and the city approved this plan in June 1959. The city went ahead and bought the church, and the EUB congregation moved to Montgomery. But this plan faced twin troubles, in the face of vocal opposition from homeowners to the condemnation of their property and a change of mind from the area merchants about their willingness to finance these purchases. The city did an about-face in September of 1960 and decided to back away from this plan. However, it was stuck with a church it neither wanted nor needed, and this later was sold to be used for office space, which remains its current use to this day.

The parking lot that the city had contemplated building in 1959 immediately north of the square, off Gregson Place, finally became a reality thirty-six years later, although the plans did change somewhat from the original—no houses were taken on Edwards or Michigan for this lot. The city bought the properties it needed on Gregson Place by eminent domain, demolished them and paved the sixty-space parking lot. The lot was ready for Hyde Park Square patrons by April of 1995.

HYDE PARK TOWN HALL

Hyde Park incorporated as a village in 1896. The meeting where the vote was held was in the building on Hyde Park Square that later was demolished to make room for the Hyde Park Savings Bank, which today is Teller's Restaurant.

A village needs a town hall, and so on December 12, 1901, the three-story Hyde Park Town Hall was dedicated at the northeast corner of the Erie Avenue and Michigan Avenue intersection at 2740 Erie Avenue. Hyde Park was annexed by the City of Cincinnati less than two years later on November 17, 1903, and the need for the town hall disappeared with the annexation. The Hyde Park Masonic Lodge, which had met in the town hall for many years, bought the building from the city in December of 1915 for $13,350.

The Masons kept the building as a Masonic Lodge until 1960, although they renovated the building in 1919 to add storefronts to the Michigan Avenue side to rent to retail tenants. The Masons sold the building in 1960 to be demolished and used as a gas station.

That corner remained a filling station, under one company's name or another, until 2003, when plans were made for an upscale condominium building, Michigan Terrace, and the service station was razed. The condominium building was completed in 2005.

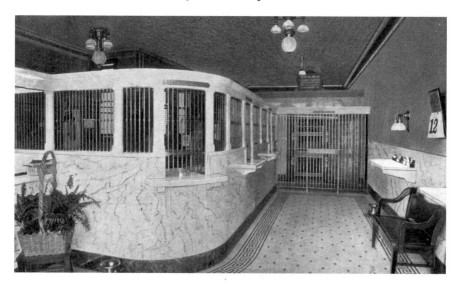

Interior of the Hyde Park Savings Bank, which today is Teller's Restaurant. Note the spittoons at the bottom left and the far right near the bench. *Courtesy of the Public Library of Cincinnati and Hamilton County.*

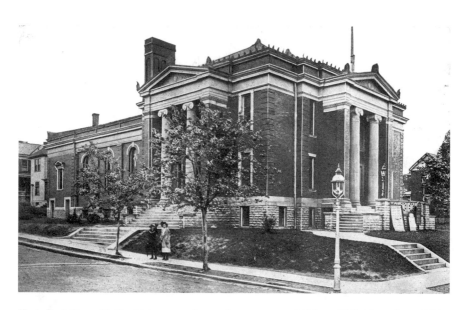

Hyde Park Town Hall, which was at the northeast corner of Erie and Michigan from 1901 to 1960. *Courtesy of the Public Library of Cincinnati and Hamilton County.*

COURTS BLOCK PLANNED EXTENSION OF HYDE PARK SQUARE

The city planning commission, after two years of study, approved a plan in November of 1933 to extend Hyde Park Square one block west, to a point one hundred feet west of Zumstein Avenue. The plan was to take a forty-foot strip from the front of the residences in that block in order to create room for another grassy square to correspond with the existing park in Hyde Park Square in the block between Edwards and Zumstein Avenues. The city changed the zoning from residential to business, and it changed the height restriction on newly built structures to encourage construction of five-story buildings in this second block of the square, similar to those on the corners of the existing square.

However, four of the property owners on this block objected to the extension of the square, in what may have been the most important of all the many Hyde Park land-use battles. The houses at issue were a part of the 102 lots in the residential part of the James Mooney subdivision, all of which contained restrictive covenants stating: "Said property herein conveyed shall be used exclusively for residential purposes."

Present-day view looking west down Erie Avenue from the square. *Courtesy of the author.*

Proponents of the extension pointed to construction of the five-story Cooper Building, at the southwest corner of Edwards and Erie; Episcopal Church of the Redeemer, immediately south of the Cooper Building on Edwards; and two office–retail buildings on Erie immediately west of the Cooper Building as having effectively changed the block to a business use. However, the opponents to this change in zoning were able to show that each of these buildings in question was built with the consent of every one of the landowners in the Mooney subdivision.

In a pair of 1938 decisions, the Hamilton County Court of Common Pleas and the Court of Appeals for Hamilton County found the restrictive covenants were enforceable and that the zoning restrictions could not trump them.[38] The planned expansion of the square was effectively at an end.

CHAPTER 11
AULT PARK

The 224 acres of Ault Park begin at the eastern terminus of Observatory Avenue. The center of the park is dominated by the Ault Park Pavilion, where two grand staircases make their way from the park floor to the main level of the grand Italianate pavilion with a fountain cascading between the staircases twenty feet to the ground.

Looking west from the front steps of the pavilion lay formal gardens of a great variety of flowers and trees. From the rooftop of the pavilion, one can look west and see at least as far as Withrow High School. To the east lies the Little Miami River and to the south are the runways of Lunken Airport. Nature trails surround the northern and eastern ends of the park. The park's southern vista finds picnic areas and a large children's play area.

On an average summer day, the park will see some combination of picnickers, sunbathers, runners, bicyclists, groups playing ultimate frisbee and the occasional Scout meeting or soccer game. The park board rents the pavilion for weddings, and many an outdoor summer wedding will be held there. The Concours d'Elegance, a classic car show, has been held in the park for many years.

The park was the brainchild of Levi Ault. He and his wife donated 205 of the park's 224 acres beginning in 1911, and the park was named for him. There is a bronze plaque sculpted by Clement J. Barnhorn, honoring Ault, affixed to a boulder of rose granite immediately south of the pavilion.

It took some time to organize the park after Ault made his initial donations. The pavilion was dedicated July 4, 1930—before the gardens

Present-day view of Ault Park Pavilion, which was dedicated on July 4, 1930. *Courtesy of the author.*

View from atop Ault Park Pavilion, looking west across the great lawn. *Courtesy of the author.*

Ault Park

Scene from Ault Park's Heekin Overlook of Lunken Airport, which was the site of Columbia, the first white settlement in southwest Ohio in 1788. *Courtesy of the author.*

were complete—in a ceremony where Ohio governor Myers Y. Cooper and Speaker of the House of Representatives Nicholas Longworth, both Hyde Park residents, delivered addresses. The pavilion was constructed on the highest knoll in the park and it commands a sweeping 360-degree view. The original entrance to the park was via Principio Avenue on the south.

The *Cincinnati Times Star* reported upon the 1930 opening of the park that:

> *The plan probably will be ten years in the making with the first unit now complete, it being the shelter structure. A tremendous amount of planting will have to be done as hundreds of trees and many groups of shrubbery will be placed.*
>
> *The plan works down a hillside and leads into what will be a new entrance to Ault Park, being a direct extension of Observatory Avenue. This is being constructed. The road leads through a ravine which adds to the picturesqueness of the setting, although some of those who are familiar with the park have protested against this. They claim the road broke up the most attractive sections of the place.*

The ravine traversed by Observatory remains a favorite to this day. On a sunny spring or summer afternoon, scores of sunbathers will be present, taking in the scenery while listening to their music.

Saturday night dances from the 1930s through the 1960s became the rage with teenagers and young adults. Many people from that era fondly recall them. Today, the park has returned to hosting several summertime dances, which are still well-attended. Independence Day sees an annual daylong fair, which is topped off by a band concert and concluded with fireworks. The Smittie Memorial Concert Green, near the pavilion, was dedicated on June 14, 1987, in honor of George C. "Smittie" Smith, a music teacher at Withrow High School, who led concerts there for fifty years.

The formal gardens originally were laid out by George Kessler, but this design was modified by nationally known landscape architect A.D. Taylor. The gardens consisted of annual flowers in the formal beds and perennials, including peonies and iris, found beneath large English oaks that flank the grassy areas in front of the pavilion. A large dahlia garden transferred from the Fleischmann Gardens remained until 1983, when the dahlias again were moved to the Hauck Botanical Garden. Those flowers were missed, though, and a new dahlia garden was added again to Ault Park in 1987.

The north garden off of the grand grass alley was redesigned in 1958 and a rose garden was planted. But this garden was discontinued in 1978 due to city budget cuts. In 1979, the park board tried to maintain the garden with volunteers, but this did not meet with success. Instead, the park board tried a different approach in 1980 when it organized an Adopt-A-Plot garden concept. This idea proved to be very successful, and it won national recognition in 1983 when it received the Daniel Flaherty Park Excellence Award presented by the Chicago Park District and the Great Lakes Park Institute.

Blanche McAvoy donated her lifetime collection of Old Fashioned Roses to the park in 1964, and these were planted to surround the dahlia garden. After twenty years, the park board volunteers decided to revitalize the McAvoy Old Fashioned Rose collection and, in 1985, the Hilda Rothschild Memorial Old Fashioned Rose Garden was established. The original collection of rose bushes was rejuvenated and two hundred new roses were planted. Also, in 1985, the tree grove around the perimeter of the formal garden was replanted as well to replace many of the original flower trees that had died.

Time has a way of changing many things, and it changed Levi Ault's park, too. During the 1960s, the pavilion began to fall into disrepair, along

The Garden of Old Roses in Ault Park. *Courtesy of the author.*

with portions of the rest of the park. The city did not have the money to rehabilitate the pavilion, and by the 1970s it had deteriorated to such an extent that the pavilion was closed and fencing was placed around it to prohibit access. A number of people thought that the entire park had become unsafe, too, due to hooligans and hoodlums. In 1980, city councilman Joseph M. DeCourcy called for the park's closing. He stated that lawlessness at Ault Park "has reached a critical juncture." He cited heavy vehicular traffic, the open consumption of liquor and drugs and groups of marauding teens that caused families to stay away.

But the park did not close. Through city funding and the determined efforts of Jim Mussio and the Friends of Ault Park, it was restored. Private and public monies were raised and the city and private volunteers both were instrumental in the restoration. After the grand cascading fountain of the pavilion had ceased flowing for almost twenty years, the fountain was restarted on July 4, 1987, and it continues more than two decades later.

The park has become again an urban oasis frequented by young and old, families and individuals. It hosted the Cincinnati Flower Show for many years until the show outgrew the park and moved to Coney Island. Today, the two biggest events that the park hosts are the July 4 activities and the

This was the state of the Ault Park Pavilion steps in 1982. *Courtesy of Rob Kranz.*

The 1982 view of the pavilion rooftop, looking west. *Courtesy of Rob Kranz.*

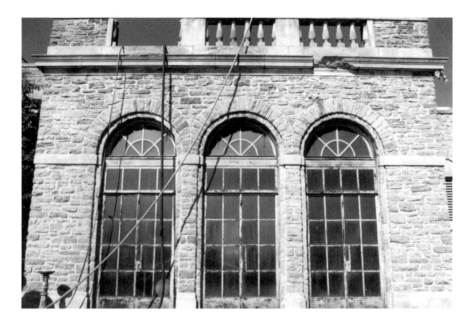

Above: View of the pavilion exterior, with missing section of balcony fence. *Courtesy of Rob Kranz.*

Right: Interior view of the pavilion before its renovation. *Courtesy of Rob Kranz.*

Reggae Run, hosted by the family of Maria Olberding, who was killed on the streets of Hyde Park by a deranged teen in 1994 while she was training for the Boston Marathon. The run is held in her memory on the first Saturday of each October, and it draws thousands who run, listen to the reggae music with friends and raise money for charity.

LEVI ADDISON AULT

Levi Ault (1851–1930) hailed from Mille Roches, Ontario, where he was born in 1851. An older brother moved first to Wisconsin, and then to Cincinnati in 1876; Levi soon followed. Ault took a job in Cincinnati as a salesman with a manufacturer of lampblack, pitch and rosins. He learned enough in this business that he decided to start an ink manufacturing business of his own.

In July 1878, Ault started the Ault & Wiborg Company, a manufacturer of printing inks and dry color dyes and pigments. Ault and Frank Wiborg, four years Ault's junior, invested $10,000 apiece and opened the company on New Street downtown, though the manufacture later moved to Saint Bernard near Ivorydale. Within five years the company was doing so well that Ault took his wife on a belated honeymoon to Europe. His travels gave Ault the idea to establish sales offices overseas, and he did so in Toronto, London, Buenos Aires, Shanghai and Manila. The firm became a worldwide leader in the manufacture of colored inks beyond simple black inks, which generated high demand worldwide. Toulouse-Lautrec was one of many artists to use Ault & Wiborg inks in his printmaking. Ault made sufficient money that by 1910 he had homes in Cincinnati, San Francisco, Havana, Mexico City and Paris.

While the business did very well before World War I, the Great War was a turning point for Ault & Wiborg. Many dyes and other products used in the worldwide ink manufacture industry came from Germany, and those items suddenly became unavailable due to the war. Ault & Wiborg seized this opportunity. Ault increased the company's capital stock from $2 million to $10 million in order to enlarge manufacturing capacity and to fill the void left by the Germans as a result of the war.

Fortuitously, Ault sold the business in advance of the Great Depression. The company sold its dye factories in Saint Bernard and Norwood to Ciba, Geigy and Sandoz in 1920, and it later sold its ink manufacture in 1928, to the International Printing Ink Company, for $14 million. At the time of the

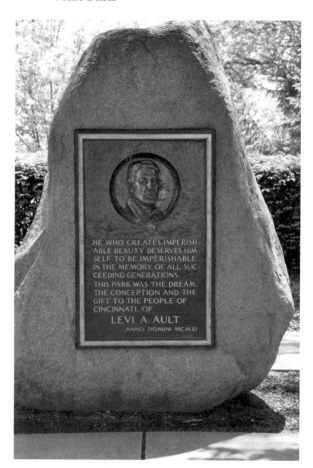

Right: Clement Barnhorn bronze plaque honoring Levi Addison Ault for his creation of Ault Park. *Courtesy of the author.*

Below: The grand home of Levi Ault, founder of Ault & Wiborg Company, which manufactured printing inks. *Courtesy of the Public Library of Cincinnati and Hamilton County.*

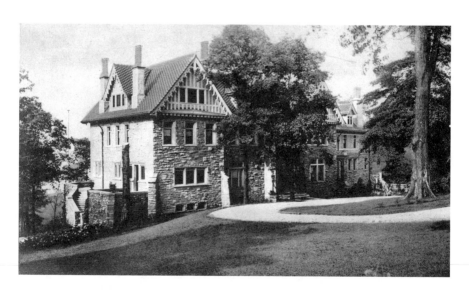

sale, Ault & Wiborg was the international leader in the ink industry with operations on four continents.

Ault & Wiborg was memorialized in the Union Terminal train station on the western edge of downtown Cincinnati, which was completed on March 31, 1933. Its train concourse was decorated with art-deco tile murals, which recognized industries and companies native to Cincinnati. One of these murals, which since has been moved to the Terminal 3 of Greater Cincinnati–Northern Kentucky Airport at baggage carousel 4, shows an operator discharging finished printing ink from a three-roller mill from the Ault & Wiborg Company.

Ault was a naturalist and he had a passion for the development of Cincinnati parks. In 1906, he headed a committee to initiate a park system, and, in 1908, he became president of the first Cincinnati Park Commission. Three years later, he and his wife, Ida May Ault, donated 142 acres to the city for the park that later was named after them. The Aults made nine subsequent donations of land that constitute 205 of the park's 224 acres. Ault became known as the Father of the Cincinnati Park System, and he remained president of the park board until 1928. He passed away two years later, in 1930, at age seventy-nine.

THE CINCINNATI OBSERVATORY CENTER

The Cincinnati Observatory Center, founded in 1843, was the first observatory in the United States. It originally was housed atop Mount Adams. With the commercial development around Mount Adams over the ensuing years, the air quality around the observatory became unacceptable for its astronomy needs. John Kilgour, who was simultaneously trying to develop Hyde Park and Mount Lookout, donated four acres of land and $10,000 to move the observatory in 1873 to the Hyde Park–Mount Lookout area. Today, the Cincinnati Observatory Center is still in use and it now is housed in two buildings, one of which contains the original 1843 telescope.

The observatory was the brainchild of Ormsby MacKnight Mitchel (1809–1862). Mitchel was educated at West Point, in the same class as eventual Confederate generals Robert E. Lee and Joe Johnston. There, Mitchel studied astronomy as part of his civil engineering classes, and he returned to Cincinnati thereafter. Mitchel became a student of astronomy, and, in 1840, he became determined to disprove a statement made by the Astronomer Royal of England that it was impossible to build and maintain an observatory in the United States. President John Quincy Adams in 1825 had recommended that Congress fund the construction of an observatory, but it went nowhere, lending support to the Englishman's notion that it could or would not be done in America.

O.M. Mitchel developed a five-year plan in 1840 to accomplish his goal of an American observatory, and he proceeded to give a series of lectures on astronomy to college students in Cincinnati and later to general audiences

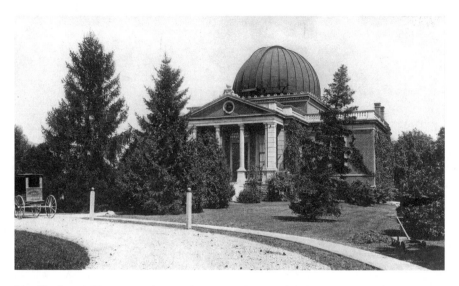

The Cincinnati Observatory Center, circa 1910. *Courtesy of the Public Library of Cincinnati and Hamilton County.*

in Boston and New York. The lectures were a rousing success, and Mitchel became famous as an authority on the subject. His newfound fame helped to build interest in his goal of constructing an observatory. The Cincinnati Astronomical Society began on May 1, 1842, with 274 charter members who comprised the cream of Cincinnati society—names such as Burnet, Drake, Dennison, Groesbeck, Hurd, Kilgour, Longworth, McAlpin, Shillito, Taylor, Torrence and Yeatman. Also members were C.E. Stowe, father of Harriett Beecher Stowe (author of *Uncle Tom's Cabin*), former president Martin Van Buren and Tyler Davidson. Later in 1842, Nicholas Longworth donated four acres of land in what was then known as Mount Ida, and the leading citizens of Cincinnati donated the funds for purchase of the telescope and the construction of the building to house it. Former president John Quincy Adams, then age seventy-seven, traveled from Boston to Cincinnati to lay the cornerstone on November 9, 1843. It was here that he gave one of his last public speeches. City government was sufficiently impressed with Adams's visit that it renamed Mount Ida to Mount Adams.

The Mount Adams Observatory became the "birthplace of American astronomy." The original 1843 Merz and Mahler eleven-inch refracting telescope cost $9,000. This famous Cincinnati refracting telescope was used by Noah Webster to illustrate the word "telescope" in the early editions of his dictionary.

The Cincinnati Observatory Center

Mitchel met an unfortunate end after such an auspicious career. In the Civil War he was rapidly promoted to major general and fought well in the 1862 Tennessee campaign for the Union army. But he found himself on the wrong side of Union generals Don Carlos Buell and Henry Halleck. They sent Mitchel to Beaufort, South Carolina, later that year to command a small brigade of Union troops and to organize African American regiments. "I came to be buried" he said upon arrival. He promptly caught yellow fever and died within two weeks.[39]

Mitchel's observatory met a kinder fate. After thirty years atop Mount Adams, dense city development around the Mount Adams basin caused severe air pollution, which interfered with the needs of the astronomers at the observatory. John Kilgour donated land just north of then City Road (now Observatory Avenue) in 1873, and the observatory was moved to the northern end of the street now called Observatory Place, which is perpendicular to Observatory Avenue. The new cornerstone was laid later that year in a building designed by Samuel Hannaford in the Renaissance-revival style. The smaller of the two buildings presently at the Cincinnati Observatory Center, the O.M. Mitchel building, was built in 1904 and it was added on to in 1912. The larger of the two telescopes presently at the observatory—an Alvan Clark & Sons sixteen-inch refractor—was purchased in 1904, and it now sits in the main observatory building. The original 1843 telescope is housed in the O.M. Mitchel building and it is believed to be the oldest continually used telescope in the world. The University of Cincinnati owns the grounds and the buildings, but the observatory is operated by the Cincinnati Observatory Center, Inc. It is the nation's oldest professional observatory.

In 1870, most of Spencer Township[40] was annexed by the City of Cincinnati, and the neighborhood changed its name to Mount Lookout shortly thereafter in recognition of the new observatory center building. John Kilgour's goal of helping to develop his Hyde Park and Mount Lookout properties through the relocation of the observatory was at least a partial success. The oldest houses in that part of the neighborhood were 3300 Observatory Avenue (circa 1877–78) and 3459 Observatory Place (circa 1880), which belonged to the first two superintendents of the observatory. The remaining houses on Observatory Place, except for 3445 Observatory Place (circa 1923), were built between 1886 and 1904. The final development in this area took place between 1910 and 1923, principally on Avery Lane, on what was then the Fred W. Cook subdivision.

The observatory is a National Historic Landmark. Today, the observatory

center is used for class work at the university, and it also is open to the public for a variety of programs. The houses on Observatory Place and Avery Lane are now a part of the Observatory Historic District, which is designed to maintain the current appearance of these residences.

Debate continues whether the observatory is in Hyde Park or Mount Lookout. Each neighborhood will claim it for its own. A 1943 publication from the WPA Writers' Program, *Cincinnati: A Guide to the Queen City and its Neighbors*, places everything north of Observatory Avenue, including the observatory itself, in Hyde Park. Others might call it Mount Lookout. There is no clear answer.

CHAPTER 13

CHURCHES OF HYDE PARK

C hurches in Hyde Park began to form when the population expanded in Mount Lookout in the 1880s and in Hyde Park in the 1890s. Congregations grew with the increase in the population of the neighborhood, and the Presbyterian and Methodist churches grew to be the largest in their denomination in the city. A number of churches have opened and closed, but six active, vibrant churches remain. An alphabetically arranged description of Hyde Park's churches follows.

CROSSROADS COMMUNITY CHURCH

On March 24, 1996, Crossroads Community Church had its first church service at Walter Peoples Middle School at 3030 Erie Avenue. Just 11 people started the church; 450 people showed up that first day for the promise of "great music, free coffee and real topics."

This interdenominational contemporary church grew rapidly. It bought a defunct big-box hardware store in 2000 in Oakley at 3500 Madison Road. The new building opened in 2002, and it has grown larger since then. Crossroads has become one of the largest churches in Cincinnati and one of the fastest growing in the country.

EPISCOPAL CHURCH OF THE REDEEMER

The Episcopal Church of the Redeemer first held services on Sunday, October 25, 1908, in the Hyde Park Town Hall, at the northeast corner of Erie and Michigan Avenues. The church grew to sufficient size that it was able to break ground on its own building on April 11, 1914, at 3443 Edwards Avenue; this first sanctuary was complete by 1916.

The congregation outgrew its Edwards Avenue building by the early 1950s and it purchased property for a new building at the northeast corner of Erie and Paxton Avenues, at 2944 Erie Avenue. Ground was broken in June 1952 and the new church was dedicated on November 15, 1953, at a cost in excess of $500,000. The church sold its former Erie Avenue sanctuary to a property developer; the space where the former sanctuary stood is today the series of shops between Hyde Park Elementary School on the south and the Cooper Building on the north.

The church underwent a significant addition dedicated in May 2005, increasing by half the size of its building at a cost of $7.5 million including furnishings. The entire 1952 building was renovated except for the main church space. Added were places to greet newcomers, increased and improved space for education of children in the Sunday school and weekday preschool, young family worship and adult education.

FIRST CHURCH OF CHRIST, SCIENTIST

The First Church of Christ, Scientist, in Hyde Park received its charter from its national church on August 2, 1892, which was four years before Hyde Park was incorporated. It has been a part of the neighborhood since Hyde Park's beginning.

Hyde Park is infamous for its many land-use battles over more than one hundred years, and this church's plan to build its sanctuary at 3035 Erie Avenue in 1982 marked another of these struggles. The Christian Scientists bought a house at this address, across from Walter Peoples Middle School (now Clark Montessori) in 1982. Neighbors objected to the church's plan for a 1-story building and 30-car parking lot. The city planning commission eventually granted permission to proceed, and the 150-person congregation did so, building a red brick structure quite compatible with its neighbors.

Holy Angels Catholic Church

The Holy Angels Parish was founded in April 1859 for forty Catholic families in the vicinity of East Fulton (O'Bryonville, East Walnut Hills and lower Hyde Park). Archbishop Purcell blessed the cornerstone on the original church on May 1, 1861, which was located at the intersection of Torrence and Madison Roads.

Almost sixty years later, in 1920, the parish purchased the estate of former Ohio governor and United States senator Joseph B. Foraker (1846–1917) for its new church building at the northwest corner of Grandin and Madison Roads. Its old church building was sold, and it served a variety of uses until it was torn down in 1938 to make room for Torrence Parkway, which connected Hyde Park to the new Columbia Parkway.

The final day of services for Holy Angels came on November 21, 1999, which coincided with the retirement of Msgr. Robert Amann, who had been pastor for sixteen years. The archbishop had decided to merge Holy Angels parish into the Saint Francis De Sales Parish in East Walnut Hills.

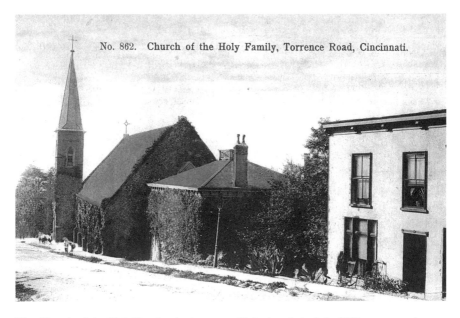

No. 862. Church of the Holy Family, Torrence Road, Cincinnati.

The Church of the Holy Family, also known as Holy Angels, built in 1860, was near the top of Torrence Road at Madison Road. It was torn down in 1938 to make room for Torrence Parkway, which was 350 feet west of the road. *Courtesy of the Public Library of Cincinnati and Hamilton County.*

HYDE PARK BAPTIST CHURCH

The Hyde Park Baptist Church is the oldest Christian congregation in the Northwest Territory.[41] It was founded on January 20, 1790, as the Columbia Baptist Church in the settlement of Columbia, near where Lunken Airport sits today at the confluence of the Ohio and Little Miami Rivers. On the original site of the church, adjacent to Pioneer Cemetery on elevated ground across Wilmer Road from the airport, a pillar commemorates the courage of these Columbia pioneers. Inscribed on the pillar are these words: "The Columbia Baptist Church erected its first house of worship on this spot in 1792. The lot contains two acres of ground purchased of Benjamin Stites and was deeded to the Baptists of Columbia Township." Early minutes of the church reflect that any male member of the congregation who appeared at services without his rifle was fined two dollars—firearms were believed necessary to insure protection against Indians.

Cincinnati's original settlers were farmers, but the land in Columbia was often met with springtime floods. Many of Columbia's settlers left for higher ground, and in 1808 the church left as well, moving to Duck Creek Road and the church was renamed the Duck Creek Baptist Church. After almost seventy years, the population in Duck Creek was declining, and the church again followed, moving in 1875 to Grace Avenue in the new Kilgour development of Mount Lookout, where it became the Duck Creek Baptist Church at Mount Lookout.

The church voted in 1904 to move to the burgeoning neighborhood of Hyde Park at the corner of Erie and Michigan Avenues. Its chapel was completed in 1907 and the main sanctuary and fellowship hall at 2736 Erie Avenue were finished and dedicated on November 28, 1926. Among the speakers at the church's dedication was former Ohio governor Judson Harmon, whose father was once pastor of the church. The cost to build the facility was $130,000. Along the building's Michigan Avenue side, retail shops are open that help the church defray operating costs.

HYDE PARK COMMUNITY UNITED METHODIST CHURCH

The Hyde Park Community United Methodist Church of today started life in 1880 as the Mount Lookout Methodist Episcopal Church. John Kilgour donated a lot worth $1,600 fronting 80 feet on Observatory Avenue and

150 feet on what is now Grace Avenue. The original church building on this lot was dedicated on December 5, 1880, at a cost of $3,750. It was a 28-by-50-foot wooden structure with a 72-foot tower. The Mount Lookout ME church merged in 1922 with the Hyde Park ME church that had been formed in 1907 from a split in the Mount Lookout ME church. The new combined church, named the Hyde Park Methodist Episcopal Church, decided to tear down the 1880 Mount Lookout church building to construct a new, grand Gothic sanctuary on this site. The 1880 structure was torn down in 1925.

The current Gothic building, at 1345 Grace Avenue, was built from 1925 to 1927 and consecrated in services September 25, 1927, as the Hyde Park Community Methodist Episcopal Church at a cost of $685,000. The word "community" was added to the title of the church in April 1926 as part of the church's official policy which, in part, is:

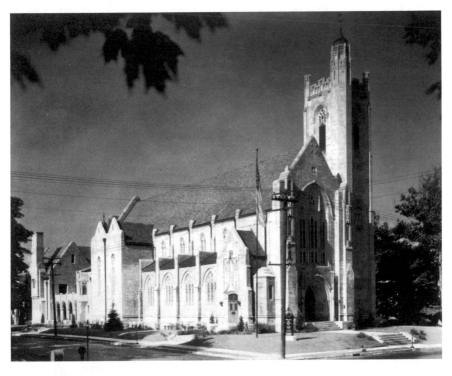

The original Gothic sanctuary of the Hyde Park Methodist Episcopal Church, photographed in 1928. Today this is the Hyde Park Community United Methodist Church. *Courtesy of Rudy Heath.*

The determined policy of this church is that it shall be a seven-day-in-the week community church. Just so far as physically possible it will be thrown open for the use of all community gatherings, community interests, community programs…The program aimed at is of such breadth, purpose and atmosphere that people will rather "be at church" than not…We will be nearing our ideal when the children and young people of all the community will prefer to be "over at the church" than anywhere else.

The education wing, which is west of the sanctuary going toward Meier Avenue, and the chapel, at the corner of Meier and Observatory, were consecrated on May 15, 1966, at a cost of $1.2 million including land. The next significant capital campaign renovated the chancel in 1999 and built the stair tower in the rear of the sanctuary, which was completed in 2001. The church's 2005 capital campaign also resulted in some significant changes to the original Gothic building. The gymnasium was converted to classrooms on the bottom floor, and a new floor was added on the second level of the gym to construct a welcome center, which was dedicated on June 10, 2007. On January 7, 2009, Hyde Park Community United Methodist Church's 1927 Gothic building was named to the National Register of Historical Places.

The Hyde Park church bought the Monastery of the Holy Name, at 3020 Erie Avenue, in October of 2001, and it has used this building for a variety of its mission projects including Meals on Wheels, Walk to Emmaus and Interfaith Hospitality Network plus needed administrative offices. The church's uses of the building brought it into conflict with its neighbors when it sought in 2005 to renovate the church building on Erie from its 1950s-era facilities. An unfortunate multiyear zoning battle ensued, which, as of this writing, is still unresolved in the courts.

HYDE PARK METHODIST EPISCOPAL CHURCH AND HYDE PARK EVANGELICAL UNITED BRETHREN CHURCH

The Hyde Park Methodist Episcopal church was founded in 1907 by 132 members who had split from the Mount Lookout Methodist Episcopal Church. It constructed a building at 2753 Erie Avenue (immediately east of the branch library), which was dedicated on January 3, 1915. The building was made of Persian buff brick, heavily ornamented with Bedford

stone. It was decorated in the style of the Greek renaissance, and it cost approximately $25,000.

It was just seven years later that the Hyde Park Methodist church merged with the Mount Lookout Methodist Church. The combined church, which took the Hyde Park name, tore down the Mount Lookout building in 1925 to construct the Gothic sanctuary at 1345 Grace Avenue. The congregation planned to meet at Hyde Park's 2753 Erie Avenue building during construction, but this changed abruptly when the church building on Erie burned on January 5, 1924. The congregation moved to the former Hyde Park Town Hall (northeast corner of Michigan and Erie Avenues then owned by the Masons) until the new Gothic complex was completed and consecrated on September 25, 1927. The Hyde Park Evangelical United Brethren bought the burned Erie building in 1924 for $15,000, which it remodeled.

Hyde Park Square has had a shortage of parking since automobiles became popular, and the city's response in 1959 was to buy the Erie Avenue building from the EUB church to tear it down for parking. However, the city's method for financing its purchase was to assess Hyde Park Square merchants, who balked at this plan. So the city ended up being stuck with a building it did not want but eventually sold in the 1960s. It has since been used principally for doctors and architects offices.

The city's efforts to improve parking for Hyde Park Square merchants in the 1960s ultimately included another piece of land that was used by the Hyde Park Methodist and the Redeemer Episcopal churches in their formative years. On land then owned by Wallace Burch, a building called the Methodist Tabernacle was erected. It was a thirty-by-sixty-five-foot wooden building with a gabled roof. That parcel and others located between Michigan Avenue and Edwards Road north of Gregson Place and behind the buildings that face south on Hyde Park Square presently constitutes that long-awaited city parking lot in Hyde Park.

Knox Presbyterian Church

Knox Presbyterian Church is another church that began with the initial, rapid growth of Hyde Park. The Presbytery of Cincinnati established Knox on July 10, 1895, the year before Hyde Park became a village. The thirty-four church members met on the second floor of a feed store on what became Griffiths Avenue—Saint Mary parish would start meeting in this same room, three years later.

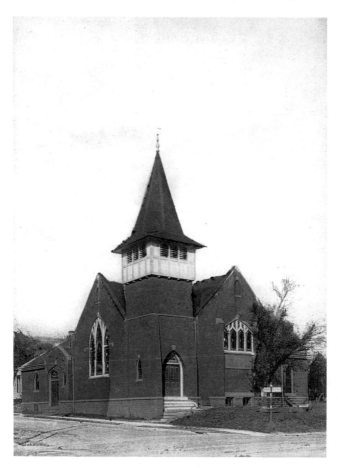

The original building of the Knox Presbyterian Church, at the corner of Erie and Shaw, was used by the church from 1896 to 1929. *Courtesy of the Public Library of Cincinnati and Hamilton County.*

The Hyde Park Syndicate offered the church a 50-foot by 150-foot lot—the standard Hyde Park-sized lot—at 2800 Erie Avenue, at the corner of Shaw Avenue. There the church laid the cornerstone on October 14, 1895, for its $10,000, 250-person sanctuary. The building was dedicated on April 7, 1896.

The church grew substantially during these early years to the point where it had outgrown its landlocked building on Erie, and it laid the cornerstone for its new building at 3400 Michigan Avenue on April 22, 1928. The building, faced with beautiful Indiana limestone, was dedicated on May 26, 1929, at an initial cost of $360,000. The former sanctuary on Erie Avenue is still in use today as the Hyde Park Center for Older Adults.

With the church's continued expansion, it added a new school and chapel for $150,000 in the fall of 1950. The church underwent another capital

campaign in the late 1980s and early 1990s, and it raised more than $1.5 million to renovate the church, including making the building accessible to the disabled, restructuring the chapel, remodeling offices and installing new heating and air conditioning.

Knox later purchased two apartment buildings immediately to the east of its campus on Observatory Avenue, and it eventually tore them down to add onto the 1929 church building. Ground was broken on April 15, 2007, for this $6.2 million project, known as Knox Commons. This 2-story addition to the original building with a multipurpose room that seats 275 people was dedicated April 30, 2008. Contemporary worship is held there on Sundays.

MONASTERY OF THE HOLY NAME

Bayard Kilgour Sr. carved out eight acres immediately west of his estate, The Pines, and this land was sold to the Dominican Order of the Catholic Church in 1951. The Dominicans constructed their Monastery of the Holy Name at 3020 Erie Avenue, which was finished in 1953. When the Dominican Nuns first came to Cincinnati in 1915, they were located at 2824–2826 Melrose Avenue in Walnut Hills. In 1923, they moved to the northwest corner of Woodburn and William Howard Taft Road, and, in 1926, they moved to 1960 Madison Road in East Walnut Hills. The Madison Road site currently is the Saint Margaret Hall, a nursing home operated since 1962 by the Carmelite Sisters for the Aged and Infirm.

The monastery was a cloistered nunnery—the only one in Cincinnati. The nuns had little to no public contact. A public sanctuary built in the monastery was dedicated September 19, 1954, but the nun's chapel was behind the altar out of public view. The entire building is one building inside of another, to allow both public access and to keep the nuns cloistered. At one time, more than twenty nuns called this home.

The monastery is on four acres. The Dominicans found they did not need the four acres north of the monastery, and the land was sold to developers who later built Cloister Court. Some of those properties have restrictive covenants associated with them, which prohibit construction of homes that would allow a view into the backyard of the monastery, over the substantial wall.

The number of cloistered nuns diminished over the years, and the nunnery eventually closed in 1989. Friar Gabriel O'Donnell commented that "[f]or some years now, we have had no new members, and we cannot reasonably

hope for a sufficient number of vocations in the near future to warrant the attempt to prolong our stay." The building was later operated as an education and retreat center by two different organizations—the Shepherd Center, an ecumenical group (1991) and the Mater Ecclesia Institute, a Roman Catholic group (1996), but neither was able to purchase the building. The Dominicans sold the monastery to the Hyde Park Community United Methodist Church in October of 2001 for $1.125 million.

SAINT MARY CATHOLIC CHURCH

The development and growth of the Saint Mary parish also mirrors the explosive growth of the Village of Hyde Park in the late 1890s. Holy Angels parish, whose church was located near the intersection of Grandin and Madison Roads, became too crowded with the 1890s development of Hyde Park. Archbishop Elder permitted a second Hyde Park congregation to form, and on May 29, 1898, the first Mass of the new Saint Mary parish was held on the second floor of a feed store on Griffiths Avenue, which Knox Presbyterian had vacated three years earlier.

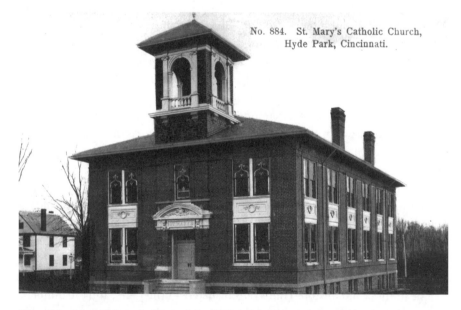

No. 884. St. Mary's Catholic Church, Hyde Park, Cincinnati.

The original Saint Mary church, built in 1903, in what is today the parking lot for the current church, which was built in 1917. *Courtesy of the Public Library of Cincinnati and Hamilton County.*

Churches of Hyde Park

A church building was needed, and, in 1901, parishioner Nicholas Walsh donated three lots on the corner of Erie Avenue and Shady Lane to the Church. The first church was built by 1903 in what is now the current parking lot behind the church. School also was held in that building beginning in 1908.

The current Gothic sanctuary at 2853 Erie Avenue was finished in 1917. A *Cincinnati Commercial Tribune* architectural review of the church from September 22, 1919, is of interest:

> *With its massive oaken doors, beamed ceiling, pointed arches and clustered shafts, St. Mary's Church, Hyde Park, rises a perfect specimen of the English Gothic architecture of the Fifteenth Century...Its construction and architecture have attracted country-wide recognition.*
>
> *The great walls, built of rugged limestone, are so constructed that they form a hollow cross. Above the main door, with its beautiful hammered iron grilling, is the statute of the Blessed Virgin and the Infant. This statute is a work of the famous sculptor, Clement J. Barnhorn.*

The Sanctuary was constructed pre-Vatican II, of course, and the altar, built of marble, originally faced away from the congregation. The communion rail was made of gray stone.

After Vatican II, the altar was reconfigured to face the congregation, and the communion railing was removed. The elevator tower on the eastern side of the sanctuary was completed as part of another renovation in 2001.

CHAPTER 14
HYDE PARK SCHOOLS

In 2010, Hyde Park has one high school, one senior high–junior high school, one kindergarten through sixth grade school, one kindergarten through eighth grade school, one school for children from three years old through high school and one school offering services exclusively to children with learning disabilities. A number of others have come and gone over the years, as well.

CLARK MONTESSORI SCHOOL

Clark Montessori was founded in the fall of 1994 in the East End as a junior high with seventh-graders who were moving on from elementary Montessori schools in the Cincinnati Public School District. Beginning the next school year, Clark became a full junior high with seventh- and eighth-graders. In the four years following, the highest grade level taught at Clark advanced each year until the 1999–2000 school year, when Clark had a full student body of grades seven through twelve and graduated its first class that year from its new Hyde Park home at 3030 Erie Avenue. Clark is the first public Montessori high school in the United States. It has been a remarkable success story for the school system—a racially integrated, top-performing school. The junior high part of Clark Montessori is made up of about 280 students and about 410 students attend the high school part of Clark.

Clark Montessori's permanent home is on the property on Erie Avenue, which is the former estate of Myers Y. Cooper, who was the governor of Ohio from 1929 to 1931.

Temporarily, Clark is located at the former Jacobs Center in Winton Place. The old Clark building in Hyde Park was razed in 2009 to make way for construction of a brand-new Clark Montessori, which is to be completed for the 2011–12 school year.

HOLY ANGELS ELEMENTARY SCHOOL

Holy Angels Elementary School, at the corner of Madison and Grandin Roads, opened September 10, 1929. Built at a cost of $170,000, Archbishop McNicholas dedicated the school that included eight classrooms, a sisters' room and an auditorium. It had room for a kindergarten, which was rare for Catholic schools at that time. Initial attendance was 260 children; the Sisters of Notre Dame de Namur ran the school.

The school met the fate of a number of urban parish schools—both the number of schools and students in parochial school today are half what they were in the 1960s.[42] Holy Angels parish school closed in 1965 due to declining enrollment. Students were reassigned to the parish schools at Saint Mary and Saint Francis De Sales. In 1981, the archdiocese sold both Holy Angels School and the neighboring Marian High School to the Springer School for $1 million. The elementary school was torn down in 1983; its former site is the Springer School playground.

HYDE PARK ELEMENTARY SCHOOL

Hyde Park Elementary School, at 3401 Edwards Avenue, has been a neighborhood landmark since it opened in 1902. Its large turrets and curved tile roof give the school the appearance of a grand castle.

There has been a school on the corner of Edwards at Observatory since 1823, when the two-room Mornington School first was built. The current three-story, red brick building was dedicated on May 22, 1902, ten years after the beginnings of Hyde Park. The student population quickly outgrew the original building, and the two-story, red brick addition was built in 1927.

Starting in the 1970s, neighborhood parents began to stop sending their children to the elementary school, and increasingly the school consisted more

The Hyde Park Elementary School was built in 1902. Today, Mount Washington Elementary uses it while its building is being renovated. *Courtesy of the author.*

and more of children bussed in from other neighborhoods. The Hyde Park Elementary School closed at the end of the 2005 school year due to lack of neighborhood support and the financial expense of operating the school. Since that time, the building has been used first by the Kilgour School and currently by the Mount Washington School, as their buildings have been renovated. The long-term use of the building has yet to be decided.

Kilgour Elementary School

Kilgour School is a neighborhood school in the Cincinnati Public School District on the border of Hyde Park and Mount Lookout. Kilgour, with about six hundred students from kindergarten to sixth grade, has received the rating of Excellent with Distinction by the Ohio Department of Education and it was the first Cincinnati Public School to receive this honor.

Mary Kilgour gave the board of education a large plot of land on Herschel Avenue to be used for a school. The school, when built, was to be dedicated in memory of her husband, John Kilgour, whose picture hangs in the main school entry.

In 1922, the first eight rooms of the Kilgour school were opened, and the building with its white colonial pillars was dedicated in Kilgour's memory. It was not long before the eight-room school was outgrown. By 1928, a new addition to the school was opened.

In 1954, another addition to the school was opened, due in large part to the postwar baby boom. Many children attending Kilgour today are children and grandchildren of Kilgour students of past generations. The school was completely gutted, rehabilitated and added onto starting in 2005 when the children temporarily attended Hyde Park Elementary School. The school reopened in the fall of 2008.

MARIAN HIGH SCHOOL

Marian High School, a Catholic girls' school, opened in the fall of 1964 at the corner of Grandin and Madison Roads, at 2121 Madison Road, next to Holy Angels Elementary School. Before this time these girls attended Saint Mary School in the space that is now the Saint Mary Elementary School— the elementary pupils used to attend school in the old church at Saint Mary, which was later torn down and currently is the parking lot in the rear of the present church.

Marian was expected to house at least six hundred girls from Hyde Park, Mount Lookout and Madisonville and was designed to help the overcrowding experienced at Saint Mary. The Sisters of Charity, who operated Saint Mary, also had responsibility for Marian.

The school operated for less than twenty years—its last graduating class was 1981—and the girls started attending the consolidated Purcell-Marian High School that fall. The Springer School purchased both Marian and Holy Angels from the Catholic Church in 1981. Springer tore down the long-vacant Holy Angels for a playground, but it continues to use the former Marian High School as its school building.

WALTER PEOPLES MIDDLE SCHOOL

In the 1960s, Withrow High School housed both senior and junior high school students and it was running out of space for students. The Cincinnati Board of Education decided a Mount Lookout Junior High School was needed, and, in 1965, it purchased the eleven-acre estate of

former governor Myers Y. Cooper, The Pines, at 3030 Erie Avenue, for this purpose.

The Walter Peoples Middle School opened on this property in 1968 and is named for a former principal of Withrow High School who had passed away from leukemia in 1947. The school opened with great fanfare, but after a few years it was attended by fewer and fewer neighborhood children, as many parents in Hyde Park chose to send their children to parochial or private schools.

The school district was focused on developing kindergarten through eighth grade schools, and this middle school had become lost. A *Cincinnati Post* article noted that:

> *Peoples Middle School is a troubled island in the middle of Hyde Park, with most of its students bussed in from surrounding neighborhoods. Like many urban schools, it struggles with discipline, attendance and achievement, although there has been some progress in the last few years.*

The decision was made later that school year to close Peoples, and its last class was in June of 1999, its 460 students dispersed elsewhere. The Clark Montessori School moved to the former Peoples's site in the fall of 1999.

Saint Mary School

The first Saint Mary Grade School opened in 1908 with 100 children and shortly thereafter a high school curriculum was added. Classes were held in the church, which at that time was located in the middle of the present parking lot. The Sisters of Charity operated the school from its beginning until 1973.

The present Saint Mary Grade School was first built as a coed high school in 1923. In 1927, the boys moved to Purcell High School; Saint Mary became an all girls' high school until 1964, when the girls moved to the new Marian High School and the grade school moved into the larger high school building. Classrooms were added to the undercroft of the church and the original grade school building was demolished to make room for a parking lot.

The parish conducted a $3 million expansion of the school and renovation of the undercroft in 1999. That construction, completed in 2000, brought all school programs under one roof. In addition to allowing for installation of the latest computer technology, the new buildings were designed to be physically accessible to everyone and adaptable for future educational needs.

SPRINGER SCHOOL

The Springer School and Center is the region's leading program devoted to educating children with learning disabilities that affect reading, comprehension, written language, memory and math skills. Springer was founded in 1887 as the Cathedral School for the Archdiocese and it served grades one through twelve. From the beginning, it served children with special needs as the original school had a program for the deaf and hard of hearing children. The program was underwritten by a bequest from Reuben Springer (1800–1884) (See Chapter 7, John and Charles Kilgour: The Money and the Vision Behind Hyde Park.), who at his death was estimated to be Cincinnati's wealthiest citizen. His will provided for a number of Catholic charities, including the formation of what has become the Springer School.

Springer ended its relationship with the archdiocese in 1971 and it became a nonaffiliated, independent school. The center, at 2121 Madison Road, has been in the home of the former Marian High School since the early 1980s. In 2010, it provides a day-school program for 206 students, ages six through fourteen. Students typically attend up to three years before returning to their old school or to another mainstream school.

THE SUMMIT COUNTRY DAY SCHOOL

The Summit Country Day School is an independent Catholic school, schooling children from ages three to nineteen.

In 1890, the Sisters of Notre Dame de Namur opened the Academy of Our Lady of Cincinnati for girls in the Notre Dame convent complex at Grandin Road and Convent Lane. Our Lady of Cincinnati became the Summit Country Day School in 1927. A boys program was added in 1941 and was known as the Summit School for Boys, for students in grades one through eight. Two of the Sisters of Notre Dame introduced Montessori education in 1963 for preschool students, and over time Summit became a leader in Montessori education. Seven years later, in 1970, Summit Primary School opened for students in grades one through three. Separate middle schools for boys and girls were established for students in grades four through eight. Boys began attending Summit Upper School in 1972 for the first time, and the school's first coeducational class graduated in 1976. Summit built a new middle school in 1987, renovated the main building and completed a range of new athletic facilities.

In January 2004, the school was in the process of constructing a new primary–Montessori building to replace its old building that had been demolished in preparation for the new building. The children were moved during the renovation to a temporary space in the large, old convent building. An exterior wall in the original convent building was weakened due to the excavation during the construction and renovation and it collapsed on Sunday morning, January 18. Had the building collapsed during the school day, scores of children would have perished.[43] Fortunately, only property damage resulted. Construction began anew, and by the fall of 2004 the new lower school opened.

WITHROW HIGH SCHOOL

In 1913, the Cincinnati Board of Education purchased 27 acres at 2520 Madison Road from the estate of Andrew Erkenbrecher, a founder of the Cincinnati Zoo, for the new East High School. Construction began in 1915 but was not completed until 1919 due to delays caused by World War I; 1,200 students enrolled that fall. The school's entrance is a footbridge

Withrow High School, built in 1919, was originally the East Side High School until it was renamed in 1924 for school board member John Withrow. *Courtesy of the Public Library of Cincinnati and Hamilton County.*

spanning a small ravine. The 114-foot clock tower, with dials facing all four directions, is the red brick school's most notable feature. Inside the tower are 110 steps leading to windows above the clock where, on a clear day, one can see for miles. The base of the tower bears an inscription from the book of Psalms: "So teach us to number our days that we may apply our hearts unto wisdom." The base of the clock tower bears a number of interesting statements that reflect a different mindset about life than what children hear today. One comment states:

> *If you want knowledge you must toil for it, and if good you must toil for it, and if you want pleasure you must toil for it. Toil is law. Pleasure comes through toil and not by self-indulgence and indolence. When one gets to love his work, his life is a happy one.*

The central building in the campus is a three-and-one-half story semicircular structure. The Hyde Park Business Club donated a Rookwood fountain and the Women's Garden Club presented the flagstones that surround the fountain. The school was renamed Withrow High School in 1924 in honor of John M. Withrow, longtime member of the board of education.

Withrow was a neighborhood high school for Hyde Park and the entire eastern side of the city until the 1950s, with more than seven thousand students in grades seven through twelve. About that time more and more students from Walnut Hills, Avondale, Madisonville and Evanston began attendance and the students from Amberley and Bond Hill were moved to the new Woodward High School near Swifton Commons. By the 1960s, Withrow's enrollment was 40 percent African American, and it saw significant racial tension, causing many Hyde Park neighborhood families to send their children elsewhere to school. By the mid-1980s, virtually no Hyde Park neighborhood children were in attendance, a trend that has continued to this day.

The outside appearance of Withrow was little changed until a vocational building was completed in 1974. The footbridge was condemned by city engineers as unsafe in 1980, but the Friends of Withrow raised $150,000 for its restoration. The restored bridge was rededicated in 1982 in honor of Nora May Nolan, a former beloved English teacher who taught at the school for many years.[44]

Withrow University High School opened as a separate school in the fall of 2002 as a college preparatory school, and it now boasts students in all

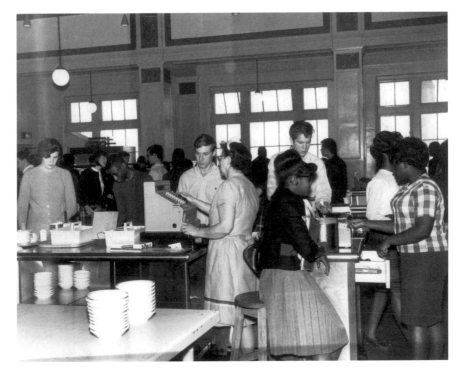

Withrow cafeteria, circa 1965. *Courtesy of Jack Cover.*

four grades. Today, the school is organized into two sections: the Withrow University High School and Withrow International High School. It has approximately 1,500 students.

SAINT MARY SCHOOL STATE FUNDING CONTROVERSY

The State of Ohio pays tax funds to parochial schools for textbooks, transportation, remedial reading, audio visual equipment and counseling services. In 1976, the Cincinnati Board of Education started withholding funds and school bus transportation to Saint Mary students after the predominantly white Hyde Park school accepted the predominantly white pupils from the closed Holy Cross school in Mount Adams, bypassing the mostly African American Saint Francis De Sales School in Walnut Hills. The board took the action to prevent plaintiffs in the pending desegregation case against Cincinnati Public Schools from claiming that the school district had

aided a segregative act. The Holy Cross and Saint Mary's parents pointed out that most Saint Francis students were not Catholic and that religious training, instruction, observation and exercises were more traditional and frequent at Saint Mary than at Saint Francis.

Court proceedings took place both in state and federal courts from 1976 through 1979. They came to an end when U.S. District Judge Timothy Hogan ruled that there was nothing discriminatory about the decision of the Holy Cross parents to send their children to Saint Mary. Hogan said "[t]he Holy Cross parents and children in selecting St. Mary's School because of religious convictions were engaged in the free exercise of religion as protected by the First Amendment...The Cincinnati Board may not interfere in the exercise of such Constitutional rights." Judge Hogan returned almost $300,000 to Saint Mary and its attorneys, and ordered state funding for nonreligious services to be restored.

CHAPTER 15

THE COUNTRY CLUBS

H yde Park boasts of two, full-service, century-old country clubs: Cincinnati Country Club and Hyde Park Golf and Country Club. Cincinnati Country Club's golf course is the oldest course west of the Allegheny Mountains. Hyde Park's course was redesigned in 1920 by famed golf architect Donald Ross. The neighborhood also is home to the ninety-five-year old Hyde Park Tennis Club, with six outdoor courts tucked in off Erie Avenue just paces from Hyde Park Square.

CINCINNATI COUNTRY CLUB

The Cincinnati Golf Club on Grandin Road opened in 1895. Nicholas Longworth, later Speaker of the House, grew up at his family's nearby Rookwood estate and laid out the first nine holes of the course. William Howard Taft was the club's first president, and its members have included Krogers, Procters, Fleischmans, Pogues and Kilgours.

The Cincinnati Country Club opened next door to the golf club on Grandin Road on July 4, 1903. The *Commercial Tribune* reported the next day that:

> *Society, in all its bravery of gay summer gowns and immaculate outing suits, appeared at the Cincinnati Country Club, in Grandin road, yesterday to make its bow very informally to the new center of gaiety. Between the hours of 4 and 5 there was a steady stream of guests, either driving in*

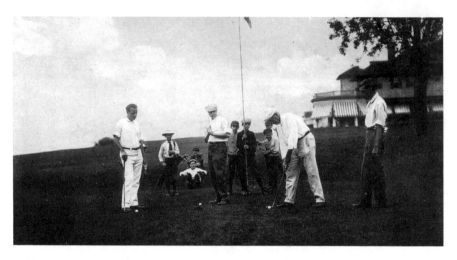

The Cincinnati Golf Club began in 1895. The original course was laid out by Nicholas Longworth. *Courtesy of the Public Library of Cincinnati and Hamilton County.*

private carriages or taking advantage of the carryalls which stood waiting at the intersection of Grandin road and Madison avenue.

No prettier summer scene can be imagined than the new club building, flaunting its many flags with each passing breeze, and with its cargo of guests taking up every available spot on veranda and through the rooms. To be sure, the verandas and lawns were the chief places in demand for the incoming guests, each of who begged and pleaded for a drink of something cool before going a step farther. But the breezes, a bit loath elsewhere, were more generous along the Grandin road, and, in spite of the intense heat. It was a very pleasant place to be.

The two clubs merged on January 1, 1924. The club has continued its reputation as among Cincinnati's elite ever since. A June 1936 society page from the *Cincinnati Enquirer* bears evidence to this:

Never has the Cincinnati Country Club been so fascinating as is the case this season. To look down from the wide windows of the circular dining room upon such a scene as last night was to feast the eye in color and beauty.

The green waters of the swimming pool, set in a sea of the matchless turn, thus far unharmed at this favored milieu by the prevailing drought, centered the admiring eye, and lifted it to the dance floor, equally embedded in close-cropped grass as green as Ireland's banners, and thence to a well

kept golf course of hills and dales—a "good player's" paradise—and so across the expanse of greensward to a radiant sky, which even last night, in the beginning of the summer solstice, was still faintly bright with the fading remnants of a dramatic sunset.

The golf course was substantially redone in 1924 and 1925 and again in 1966. Today, the bentgrass course measures 6,304 yards from the championship tees, with a slope of 130, and has a 70.8 course rating. It was one of the first 100 clubs established in the United States.

Among the favorite nineteenth-hole stories at the club is the one from when Bobby Jones played the course in the mid-1920s before his famous 1930 grand slam. Included in his foursome were the club's first pro, Otto Hackbart, and club members E.W. Edwards and Howard Cox. Jones was on the eighteenth green in sixty-one strokes, needing only two putts to beat Hackbart's course record of sixty-four. With a wink to Hackbart, Jones proceeded to three-putt the eighteenth green because he thought it important for the club pro to own the course record.

There was a time when country clubs did not need fences surrounding them, and this was true at Cincinnati as well. But time marches on, and the fireman from Engine Company Forty-six at Hyde Park Square commented about this in the July 31, 1964 edition of the *Cincinnati Post & Times Star*:

Back at the firehouse, Fireman Robert Burkhart returned from making inspection and said "no more sled riding at Cincinnati Country Club—they're putting a big fence all around it." Firemen figured youngsters have used a hill there for 50 years.

While Hyde Park has seen more than its share of land-use battles since the mid-1880s, the dispute concerning almost a third of the land underlying the Cincinnati Country Club is one of the more unique ones.

In 1987, the landowner of 40 of the club's 125 acres sought to evict it. The club leased this land under a ninety-nine-year lease it signed in 1904, in which it pledged to make payments of $2,500 per year in semiannual installments to James Hess. Owing to confusion about the identity and location of the great-granddaughter who later inherited this lease, payments in 1986 and 1987 allegedly were received late by her. The heiress sought to evict the club from her property. Lawyers from Taft Stettinius & Hollister represented the club, and they succeeded in court to prevent the eviction. The club later settled with the heiress, purchasing the property from her.

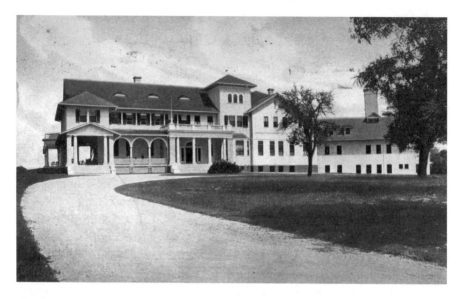

The Cincinnati Country Club began in 1903 and merged with the golf club in 1924. *Courtesy of the Public Library of Cincinnati and Hamilton County.*

Today, in addition to the golf course, the club features tennis courts, a full workout facility, swimming pool and dining and banquet facilities. A few rooms for rent are available onsite for guests of club members. And every Christmas Eve, many club members will gather for the traditional grand dinner.

HYDE PARK GOLF AND COUNTRY CLUB

The Hyde Park Golf and Country Club was organized in early 1909 and opened on July 4, 1909, in the William McCormick homestead and estate on McCormick Avenue, near what is now Marburg Avenue. That site lasted less than two years, as the clubhouse burned to the ground on March 23, 1911, due to a fire lit by accident from a plumber's torch. Within hours the club's board of directors decided to rebuild, and it selected the current site facing Erie Avenue in East Hyde Park.

The original golf course was completely redone in 1920 under the direction of Donald Ross, the most prominent golf course architect of his day, and much of the original Ross course remains ninety years later. Today, the championship tees measure 6,453 yards, with a 129 slope and a 71.7 course rating on its zoysia fairways and bentgrass greens.

The Country Clubs

Many country clubs will have their share of foursomes devoted to their weekend rounds. One member of a foursome from the 1970s took his devotion to what some might see as an extreme. The *Cincinnati Enquirer* on April 24, 1973, reported that:

> *The widow of a Hyde Park golfer has acknowledged that the ashes of her late husband, at his request, were recently strewn about the 15th tee of the Hyde Park Country Club, unfolding rather a strange story of a foursome at the club.*
>
> *Mrs. Chester C. (Chick) Guy, contacted Monday in Ft. Lauderdale, Fla., said "it is true" that Guy was cremated and that the remains were sprinkled at the 15th hole, the one members call "The Devil's Own."*
>
> *For nearly 20 years, Chick Guy, Tony Hense, Bob Anderson and Virgil Parish made up a regular foursome. They played Saturdays and Sundays and occasionally one day during the week. They shot in the 80s or 90s, "and a little worse, too." says Anderson.*
>
> *Ironically, it was also Otto Hense, "Tony" to everybody, who died first, last December, at age 79.*
>
> *Tony left a similar wish: that his body be cremated and that his ashes be ground into a particular Hyde Park sand trap on either the 15th or 16th hole—there is some confusion as to which.*
>
> *"Tony wanted to be in the trap on 15 to the right of the green," Anderson recalled Monday, "because it once took him 15 strokes to get out of there. He swore every time he saw it."*
>
> *"No, it was the 16th bunker," the wife of the deceased thought, "because he spent more time there than any place else."*[45]

Hense apparently thought better of his request and he changed his mind.[46]

The veranda of the nearly one-hundred-year old clubhouse has a lovely view of both the ninth and eighteenth greens, and it provides a welcoming, shaded spot to watch golfers finish their rounds. The club features first-rate dining and banquet facilities, as well as a swimming pool, tennis courts and paddle tennis courts. A particularly unique feature to this club is a bowling alley in the lower level, with the ability to host seventy-five bowlers and a league championship in March of each year.

HYDE PARK TENNIS CLUB

The Hyde Park Tennis Club was formed on May 11, 1915, at 2820 Erie Avenue, just a short walk from Hyde Park Square. Over the years the club has attracted a number of stars, including Bobby Riggs, Joe Hunt, Don McNeil and Frank Parker, as well as Cincinnati's own Billy Talbert.

Today, the club is open April 15 through October 15 each year, and it features six Har-Tru (simulated clay) courts.

NOTES

Farmland Becomes Mornington

1. The Treaty of Greenville—signed at Fort Greenville (now Greenville, Ohio) on August 2, 1795—put an end to the Northwest Indian war following the Native American loss to United States troops, led by General Anthony Wayne, at the Battle of Fallen Timbers. The Native Americans, which were the tribes of the Chippewa, Delaware, Kaskaskia, Kickapoo, Miami, Ottawa, Potawatomi, Shawnee, Wea and Wyandot, agreed to stay on their side of the new Greenville Treaty Line that was essentially outside of much of present-day Ohio and Indiana. Many white settlers disregarded the treaty line, encroaching on Indian land guaranteed by the treaty.

2. "Columbia" has been known as Columbia since the November 1788 landing of the first settlers in the area. It became known as Columbia Tusculum in the mid-1800s as the result of a subdivision built by Nicholas Longworth (1783–1863), who was a pioneer in American vineyards in the Garden of Eden property he owned (today's Eden Park) and in the hilly area near Columbia he named Tusculum. Longworth selected the name after the town of Tusculum, Italy, a town on the outskirts of Rome known for its excellent wines.

3. Rookwood Pottery, named for the Rookwood Estate, was started in 1880 by Joseph and Annie Longworth's daughter Maria Longworth Nichols (1848–1932) in an old schoolhouse at 207 Eastern Avenue. Maria outgrew this space, and eventually the Longworths built the grand kilns and buildings atop Mount Adams in 1891 to house the company. The

Longworths continued the manufacture of the pottery until 1941, when Rookwood Pottery went into receivership. It was bought by Marge Schott's husband, Walter Schott, and the inventory was liquidated. Very limited manufacture continued thereafter under a succession of owners. In 1960, Rookwood moved to Starkville, Mississippi, with some manufacture until 1967. Production was defunct for many years until a new owner bought a number of the Rookwood molds and began anew in 2006.

4. An omnibus was a large carriage pulled by a team of horses that would follow a regular route on which passengers could jump off and on. The omnibus later would be replaced by streetcars, which was an omnibus pulled by horses over rails. The horse drawn streetcar was replaced by the electric streetcar—a trolley—that was later replaced by city buses, which are a shortened version of omnibus.

5. The right of way for old Torrence Road north of Columbia Parkway still exists and can be seen looking north from Torrence Court and looking south from Torrence Lane, both of which are parts of old Torrence Road. George Torrence built a log cabin in 1800, which was the second house on Columbia Avenue west of Torrence Road. The cabin sat on the south side of Columbia Avenue. It was bought by the city in July of 1938 in order to be removed to make room for Columbia Parkway. Torrence's son, James Findlay Torrence (1814–1887), was prominent in his own right as a charter member and one of the most interested promoters of the Cincinnati Chamber of Commerce.

6. William Groesbeck's father, John H. Groesbeck, was an investor in Franklin Bank along with John Glenny Kilgour. (See Chapter 7, John and Charles Kilgour.)

7. Delta Avenue's name comes from the habits of the Ohio River, when flood waters occasionally backed up and formed a delta near present-day Columbia Parkway. Delta was originally Crawfish Road, named for the creek that ran alongside it. The street became Delta Avenue in 1899.

THE MORNINGTON SYNDICATE BEGETS HYDE PARK

8. Simeon Johnson (1859–1957) is described as a member of the Hyde Park Syndicate in the 1908 pamphlet *Hyde Park in Its Glory* and elsewhere. However, a review of the Hyde Park Syndicate papers at the Cincinnati Historical Society shows that this is not true. Johnson was a Cincinnati native, who graduated from the Cincinnati Law School in 1880. He practiced law for more than seventy-five years. Johnson was also active in Democratic Party politics. He was Cincinnati's vice mayor in 1912, a member of the Democratic National Committee from 1916 to 1928 and chairman of the Hamilton County Democratic Executive Committee from

1929 until 1952. Johnson made his home in Hyde Park, residing for many years at 3427 Burch Avenue, a five-bedroom house that was built in 1890.

9. *Cobb v. Bohm*, 11 Ohio Dec. Reprint 844, 1893 WL 350 (Ohio Com. Pl. 1893).

10. Burch ended up suing the other syndicate members in 1909 because he had not been paid in respect of his twenty-two years' worth of legal services. All of the monies distributed to that point were paid to the other syndicate members as interest on their initial and subsequent cash contributions, leaving nothing for dividends. There is a typewritten transcript of the 1909 trial, transcribed from the shorthand court reporting. In this transcript, Burch and others describe how both the Mornington and Hyde Park Syndicates were formed and when. Burch was victorious in the Court of Common Pleas and the court of appeals, and the case was appealed to the Ohio Supreme Court. The matter was settled, with Burch being paid $5,000 and given several lots in the Weber subdivision on the Shaw Farm, and Simeon Johnson being given several lots on Burch Avenue.

11. Syndicate to John M. Hubbell, of 3438 Edwards Road, letter, 4 June 1909, located in the Kilgour family papers at the Cincinnati Historical Society.

12. This $400,000 figure was often repeated in contemporaneous accounts of the syndicate's activities. However, the March 16, 1920 letter unwinding the syndicate says that each of the five full share members contributed $38,034.26—a combined sum of $190,171.30.

13. Clifton is a neighborhood slightly north of downtown Cincinnati that was a favorite of wealthy families by the 1850s who had left their downtown residences. Griffin Taylor, David Kilgour's stepson, was one such resident, as were future Supreme Court chief justice Salmon P. Chase, Henry Probasco and Tyler Davidson.

14. Ivanhoe was another name used for Norwood during that period.

15. The Columbian Exposition was going on then in Chicago, a tribute to Columbus's travels four hundred years earlier, American industrial progress and Chicago's rebirth after the great Chicago fire.

Old and New Plans Take Shape

16. Ziegle is named for Louis E. Ziegle, who helped establish Hyde Park as a village and became its first mayor in 1896. The path of Ziegle's driveway is today Ziegle Avenue. Victoria was named for Queen Victoria of Great Britain, who reigned from 1837 to 1901. The origination of Monteith is a bit more interesting. The original part of the street, between Observatory and Linwood, was unnamed before 1895. The road was along the estate of Policy Bill Smith, who named the road Monteith for the raucous

parties held at his mansion on the corner of Linwood. Although it may be apocryphal, Monteith apparently has two different meanings: it is an Indian term meaning "more to eat," and it is a Scottish word for silver punch bowl. The name Monteith Avenue later was applied from 1904 to 1914 to all four sections of road extending from Linwood to Wasson.

17. *Mooney v. Burch*, Case Nos. 13383-13384 (Ohio Sup. Ct.), Brief for Plaintiff in Error at 4 (1909).

18. Henry Stettinius's son was John Longworth Stettinius II (1882–1924), a founder of the law firm of Taft, Stettinius & Hollister.

19. Some family members put an *e* on the end of Handasyde.

20. James Handasyd Perkins Sr. had built Owl's Nest in O'Bryonville, a modest one-story frame house on several acres. His heirs donated the property to the Cincinnati Park Board, and that property today is Owl's Nest Park.

21. *The Cincinnati Enquirer* of March 13, 1917 reports the following Hyde Park homes as being damaged or destroyed in the tornado: 1211, 1213, 1240, 1302, 1311, 1312, 1323, 1324, 1331, 1342, 1351 and 1357 Delta Avenue; 1306, 1310, 1317, 1318, 1319 and 1330 Duncan Avenue; 1279, 1301, 1302, 1305, 1308, 1309, 1312, 1317, 1320, 1325, 1329, 1339 and 1352 Grace Avenue; 2940, 2944, 3048 and 3050 Griest Avenue; 1332, 1334, 1340, 1342, 1345, 1354 and 1360 Herschel Avenue; 2837, 2976 and 2890 Linwood Road; 1306 Meier Avenue; 1268, 1285, 1288, 1289 and 1382 Michigan Avenue; 1268, 1270 and 1311 Morten Avenue; and 2983, 2991, 2995, 3001, 3003, 3025, 3047 and 3229 Observatory Avenue.

HYDE PARK CHANGES

22. The author is a member of this Methodist Church. The building committee was chaired by someone else when the plans at issue were put into place, but that chairman moved from town in the middle of those discussions. The author then was asked to chair the committee in about 2006 and ended up knee-deep in these issues.

JOHN AND CHARLES KILGOUR

23. Griffin Taylor was very successful in his own right. He became a partner in Kilgour, Taylor and Company in 1817. By 1820, he built a mansion on the corner of Third and Vine Streets. Taylor was an organizer of the Christ Episcopal Church. He was the first chairman of the Cincinnati Chamber of Commerce and was president of the Equitable Insurance Company. Like the Kilgours, Taylor invested in Cincinnati-area land, and he was also one of the initial large landholders in the City of Chicago. At his death in 1866, Taylor was one of Cincinnati's wealthiest citizens.

24. Citizens Bank later became a part of the Central Trust Company, which today is a part of PNC Corporation.

25. The State of Ohio issued a charter to the Little Miami Railroad Company on March 11, 1836. John Glenny Kilgour was among its officers; he was the auditor at the outset. Construction of the track began in 1837, from Cincinnati north to Fosters and from Xenia south. The track followed the Ohio River from downtown to the Little Miami River and then it veered northward along the Little Miami. The first part of the track was completed to Milford by December 1841, a distance of fourteen miles. Shortly thereafter it was completed to Fosters. In August 1845, service began between Cincinnati and Xenia. By 1846, the track was completed to Springfield, a distance of eighty-four miles. The Columbus & Xenia Railroad was finished by 1849, and the two lines were connected on February 20, 1850. Between 1841 and 1851, the LMRR was the only railroad exiting Cincinnati.

 The Little Miami Railroad leased itself to the Pittsburg, Cincinnati & St. Louis Railway Company on December 1, 1869 for an annual 8 percent rental on its capital stock. Operation of the road was maintained by the Pennsylvania Railroad Company, and the LMRR remained among the most profitable roads in the United States. The line continued to be used until 1976.

 Today, the largely wooded corridor where the railroad used to run is the Little Miami Bike Trail, which stretches seventy-eight miles from Springfield to Newtown. There are plans to connect the trail to downtown Cincinnati.

26. Delta Avenue runs along what used to be Crawfish Creek. The original end of the dummy line was at Mount Lookout Square, where the present-day UDF sits. In 1873, the dummy line was extended to St. Johns Park.

27. At the time of the gift, the only public school in Mount Lookout was a small, two-room building on Delta Avenue across from Niles Avenue where a stately red brick building owned by Cincinnati Bell stands today.

MYERS Y. COOPER

28. Wasson Road is named for Jacob Wasson, who in 1864 bought thirteen acres out of the estate of Henry Morten Jr.

29. Owners of the ABC included R.K. LeBlond, founder and owner of the LeBlond Machine Tool Company; Bolton Armstrong, president of Mabley & Carew, a Cincinnati department store; James Orr, president of Potter Shoe Company; William and Charles Williams, owners of the Western and Southern Life Insurance Company; and Anson Fry, vice president and sales manager of the Gibson Art Company, which later became Gibson Greetings.

30. After many years of use as a state office building, the Ohio Supreme Court in 2001 took control of it and, after three years of renovation, opened the

new Ohio Judicial Center on February 17, 2004. The author argued a case to the court in November of 2009—the restored building is magnificent.

The Pines

31. This estimate (conservatively) assumes houses on average in this tract at $500,000 in 2010 dollars. The estimate further assumes the two churches on the north side of Erie Avenue to be worth at least $2 million each, the church on the south side of Erie at $500,000 and the eleven-acre parcel where Clark Montessori sits at $6.6 million ($600,000 per acre). This comparison improperly compares nominal versus real dollars, but the scale of the difference still would be immense even with a real dollar comparison.

32. The original Wade purchase of 160 acres had been reduced by a sale of several acres south of present-day Observatory Avenue, when this street was moved slightly northeast, cutting off several acres of the southeast corner of the tract.

33. This portion of Victoria was the development to the east of Paxton Avenue. Cooper had earlier developed Victoria west of Paxton out of a different tract.

34. There was an additional eight-acre tract immediately to the west of the eleven-acre Pines property that John Kilgour had put into a trust. This eight-acre tract was given to the Dominican Order in 1951 to build its Monastery of the Holy Name, completed in 1953, at 3020 Erie Avenue, for use as a cloistered nunnery. The Dominicans did not develop the northern four acres, and they later sold this land to developers for what became Cloister Court. The number of nuns decreased over the years, and the Dominicans eventually had no use for the building. They sold the building to the Hyde Park Community United Methodist Church in 2001.

Hyde Park Square

35. The quotes from Sanders and Uebelacker are from the *Cincinnati Post*, October 24, 2003, A1.

36. A developer bought more than twenty-nine acres at what today is Hyde Park Plaza, originally called the Eastern Hills Shopping Plaza, to develop it for larger retail stores than space permitted in Hyde Park Square. A zoning change, from residential to business, was necessary to accomplish this in order to develop the land which was undeveloped at that time. This resulted in another Hyde Park land-use battle that lasted from March of 1957 until July of 1960. Opponents fought the change, calling it a "death trap," due to

increased traffic at Paxton and Wasson Avenues. The dispute went through several rounds of court fights, before the courts granted the zoning change. The Plaza finally opened for business on November 29, 1962.

37. For many years the enormous R.K. LeBlond Machine Tool plant, at the southwest corner of Madison Road and Edwards Avenue in Norwood, lay vacant as the business was sold to foreign owners and moved to a new, modern plant near Mason, Ohio. What to do with the former tool plant was the subject of a number of plans that did not come to fruition until 1993 when the Rookwood Pavilion was built, followed several years later by the neighboring Rookwood Commons. Drew's Bookshop, at 3524 Edwards Avenue, was one of the first stores whose demise was attributed to the Joseph-Beth Booksellers in Rookwood and the Barnes & Noble bookstore in Hyde Park Plaza.

38. *Kokenge v. Whetstone*, 4 Ohio Supp. 207 (Ct. Com. Pl.), *aff'd*, 60 Ohio App. 302, 20 N.E.2d 965 (Ham. Cty. App. 1938)

The Cincinnati Observatory Center

39. Mitchel is remembered in Greater Cincinnati. The O.M. Mitchel building at the observatory, constructed in 1904, bears his name. Fort Mitchell, Kentucky, home to a civil war fortification surveyed and laid out by Mitchel, was named for Mitchel on February 14, 1910. (Although U.S. cities named for Mitchel use two *L*s rather than the one he used.)

40. The Spencer Township Hall, built in 1860, still stands at 3833 Eastern Avenue in Columbia Tusculum.

Churches of Hyde Park

41. The Ordinance of 1787 created the Northwest Territory, which comprised Ohio, Indiana, Illinois, Michigan, Wisconsin and part of Minnesota. This was the most significant legislation passed by Congress under the Articles of Confederation. It decreed that three to five states be created out of the territory and it created rules by which these new states would be admitted to the Union. It further guaranteed religious freedom and trial by jury, prohibited slavery in this newly formed territory and encouraged free public education.

Hyde Park Schools

42. This is according to the National Catholic Education Association. See the *Wall Street Journal*, February 2, 2010, A17.

43. Each of the author's three children attended the two year prekindergarten Montessori programs at Summit. The author's youngest, Caroline, started there just two weeks before the building collapse. Her after-school room was on the first floor of that building, which became a pile of rubble that Sunday morning.

44. Ms. Nolan must have had quite an effect on people, for her sister, Monica Nolan, also raised money for the renovation of the cascading fountain in the Ault Park Pavilion in Nora May's name. Nora May Nolan was a leader in arranging the annual July 4 band concert and fireworks at the park.

THE COUNTRY CLUBS

45. Anyone who has played this wonderful course will have no doubt the request was to have the ashes strewn in the right bunker on 15. Many golfers have spent more than their fair share of time in this sand trap.

46. While few would consider caddying to be particularly dangerous, two Hyde Park caddies have lost their lives on the course. William Pruess Jr., age twelve, died June 17, 1943, several days after he suffered head injuries after being struck by a golf ball. And Sam Romanello, also age twelve, died on October 18, 1958, after he threw a pressurized can into a trash fire and the can exploded, slashing his throat.

BIBLIOGRAPHY

Articles

Cincinnati Commercial

Cincinnati Commercial Tribune

Cincinnati Enquirer

Cincinnati Post

Cincinnati Post and Times-Star

Cincinnati Times-Star

City of Cincinnati Conservation Guidelines, Observatory Historic District, www.ci.cincinnati.oh.US/cdap/downloads/Cdap-3692.pdf

Hayes, Seth. "The Shaw Mastodon: Examination and Description of Mastodon and Accompanying Mammalian Remains Found Near Cincinnati, June 1894." *Journal of the Cincinnati Society of Natural History*, Vol. 17 (1895).

Jones, John Paul. "The Hermitage, The Pines and Old Hyde Park," *Bulletin of the Cincinnati Historical Society* 30 (1972).

———. "A History of The Pines," *Bulletin of the Cincinnati Historical Society* 25 (1967).

Kelly, Lora. "The Home Builder Who Became Governor: An Exclusive 'Brighter Homes' Interview with the Chief Executive of Ohio," *Brighter Homes Magazine* 2, no. 5 (1929).

New York Times

Sauers, Jennifer. "A Whirl and a Shriek: The East End Tornado of 1917," *Hyde Park Living* 29, no. 3 (March 2010).

Warminski, Margo. National Register of Historic Places Registration Form for La Tosca Flats. 1998. www.ohiohistory.org/resource/histpres/docs/nr/nr 08-05.pdf.

White, John H. Jr. "By Steam Car to Mt. Lookout: The Columbia and Cincinnati Street Railroad," *Bulletin of the Cincinnati Historical Society* 25 (April 1967).

BOOKS AND MANUSCRIPTS

Cooper, Myers. Dictation to Martha Kinney Cooper, Dec. 3, 1941. Maintained by Randy Cooper at the Myers Y. Cooper Company. Cincinnati, OH.

———. Outline. Undated. Maintained by Randy Cooper at the Myers Y. Cooper Company. Cincinnati, OH.

Cooper, R.K. Recollections of the American Building Corporation. Sept. 11, 1978. Maintained by Randy Cooper at the Myers Y. Cooper Company. Cincinnati, OH.

De Chambrun, Clara Longworth. *The Making of Nicholas Longworth*. New York: Ray Long & Richard R. Smith, Inc., 1933.

Dwyer, Doris. *The Kilgour Family in Cincinnati*. Cincinnati, OH: Young & Klein, Inc., 1983.

Erie Avenue File, Cincinnati Historical Society. Cincinnati, OH.

Giglierano, Geoffrey and Deborah A. Overmyer. *The Bicentennial Guide to Greater Cincinnati: A Portrait of 200 Years*. Cincinnati, OH: Cincinnati Historical Society, 1989.

Hurd, Dena D. Soekland. *A History of the Genealogy of the Family of Hurd in the United States and a Partial History of the New England Families of Heard and Hord*. New York: General Books LLC, 1910.

Hyde Park Business Club. *Hyde Park in Its Glory: An Historical Sketch*. Cincinnati, OH, July 1908.

Hyde Park Neighborhood File, Cincinnati Historical Society. Cincinnati, OH.

Hyde Park Syndicate Papers, Cincinnati Historical Society. Cincinnati, OH.

Jones, John Paul. "The Boston Perkins Family in Cincinnati." Unpublished. 1977. Cincinnati Historical Society. Cincinnati, OH.

Judy, Mills. *Appraisal of Building, Northeast Corner of Erie Avenue and Edwards Road, Hyde Park, Cincinnati, Ohio*, 1940. Maintained by Mike Judy at the Hyde Park Lumber Co. Cincinnati, OH.

Kilgour Family Papers, Cincinnati Historical Society. Cincinnati, OH.

Maxwell, Sidney D. *The Suburbs of Cincinnati: Sketches Historical and Descriptive.* Cincinnati, OH: self-published, 1870.

Mornington Syndicate Papers, Cincinnati Historical Society. Cincinnati, OH.

Walker, Harvey. *Constructive Government in Ohio: The Administration of Governor Myers Y. Cooper.* Columbus, OH: Ohio History Press, 1948.

WPA Writers Project. *Cincinnati: A Guide to the Queen City and its Neighbors.* Cincinnati, OH: Wiesen-Hart Press, 1943.

Wulsin Family Papers, Cincinnati Historical Society. Cincinnati, OH.

WEBSITES

Andrew Johnson. www.andrewjohnson.com.

Ault and Wiborg. www.colorantshistory.org/aultwiborg.html.

Ault Park. www.aultparkac.org/aultparkhistory.php.

Cincinnati Memory Project. www.cincinnatimemory.org.

Cincinnati Observatory Center. www.cincinnatiobservatory.org.

Clark Montessori Junior and Senior High School. clark.cps-k12.org.

Crossroads Community Church. www.crossroads.net.

Episcopal Church of the Redeemer. www.redeemer-cincy.org.

Hamilton County Auditor. www.hamiltoncountyauditor.org.

Hyde Park Baptist Church. www.hpbc.org.

Hyde Park Community United Methodist Church. www.hydeparkchurch.com.

Hyde Park Golf and Country Club. www.hydeparkcc.com.

Hyde Park Tennis Club. www.hydeparktennisclub.com.

Kilgour Elementary School. kilgour.cps.k12.org.

Knox Presbyterian Church. www.knox.org.

Ohio Historical Society. www.ohiohistory.org.

Public Library of Cincinnati and Hamilton County. library.cincymuseum.org.

Saint Mary Church and School. www.saintmaryhydepark.org.

Spring Grove Cemetery. www.springgrove.org/sg/genealogy/sg_genealogy_home.shtm.

Springer School. www.springerschool.net.

Summit Country Day School. www.summitcds.org.

Withrow High School. withrowuniversityhs.cps.k12.org.

INDEX

ABOUT THE AUTHOR

Greg Rogers came to Hyde Park in 1989 after graduation with distinction from the Emory University School of Law, where he was on the editorial board of the *Emory Law Journal*. He graduated earlier from Miami University with a degree that included a minor in history and recognition in a national history honorary. Greg was editor in chief of *Recensio*, Miami's award-winning yearbook.

Greg is a longtime member of the Hyde Park Community United Methodist Church and has served in a variety of positions, including most recently as chair of the Board of Trustees. In this role he had the opportunity to testify before the Cincinnati Zoning Board of Appeals. Two of his children attend Hyde Park's Saint Mary School, and his oldest daughter attends Saint Ursula Academy. At Saint Mary, Greg has served as head of the Cub Scouts and coached basketball while also teaching debate to the junior high. He participated for a dozen years in the Saturday Morning Running Group, which meets at 7:00 a.m. at the corner of Delta and Observatory Avenues.

ABOUT THE AUTHOR

He is co-chair of the Labor Department at Taft Stettinius & Hollister where he has worked for twenty-one years. His practice focuses on all labor and employment issues but especially on traditional labor matters and ERISA class-action litigation.

Greg continues to enjoy Hyde Park with his wife, Kathy, and three children, Samantha, Parker and Caroline.